DRAWING
you can do it!

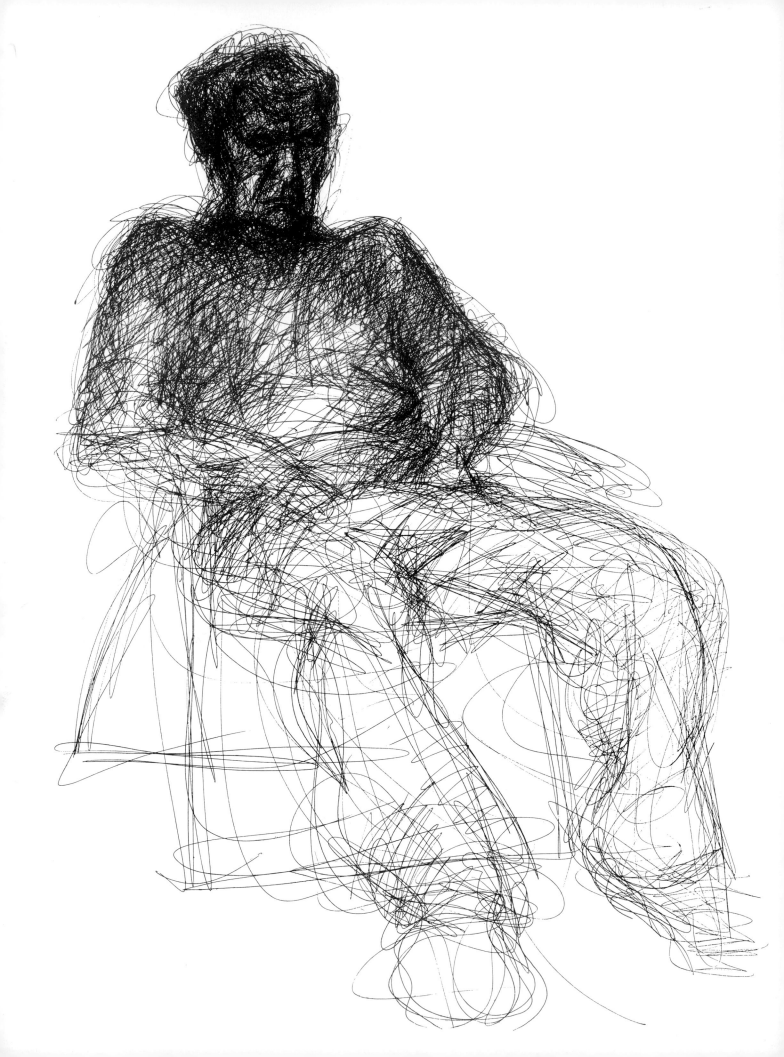

DRAWING
you can do it!

by Greg Albert

NORTH LIGHT BOOKS

Cincinnati, Ohio

About the Author

Greg Albert graduated from the Art Academy of Cincinnati in 1975. He received a B.F.A. from Northern Kentucky University in 1976 and an M.F.A. from the University of Montana in Missoula in 1978. He teaches drawing and painting at the Academy in the school's evening program, which he also directed for several years. He received a Master's Degree in art history from the University of Cincinnati in 1985, while he also lectured at Miami University in Oxford, Ohio. In 1986, he became the editor of North Light Art Instruction Books. He edits a line of drawing and painting books covering all mediums by some of America's best representational art teachers. He lives in Cincinnati with his wife and two children.

Drawing: You Can Do It! Copyright © 1992 by Greg Albert. Printed and bound in the United States of America. All rights reserved. No part of this book may be reproduced in any form or by any electronic or mechanical means including information storage and retrieval systems without permission in writing from the publisher, except by a reviewer, who may quote brief passages in a review. Published by North Light Books, an imprint of F&W Publications, Inc., 1507 Dana Avenue, Cincinnati, Ohio 45207; 1(800)289-0963. First edition.

96 95 94 93 92 5 4 3 2 1

Library of Congress Cataloging in Publication Data

Albert, Greg
 Drawing : you can do it / Greg Albert.
 p. cm.
 Includes bibliographical references and index.
 ISBN 0-89134-428-4
 1. Drawing—Technique. I. Title.
NC730.A524 1992
741.2—dc20 92-17761
 CIP

Edited by Rachel Wolf
Designed by Paul Neff

Acknowledgments

This book is the product of many people's efforts. I would like to acknowledge the following: Rachel Wolf for being a great editor—sympathetic, knowledgeable and firm; Kathy Kipp for taking care of so many details with a smile; David Lewis for his support and encouragement for an "author at work"; Paul Neff for his inspired book design; and to my students who gave me more than I ever gave them.

Dedication

To my wife, Mary Beth, for her unfailing support and patience, and for giving me a most precious commodity: time to write and draw.

To Mom for encouraging a son who chose an impractical artistic career.

To Dad for countless and patient hours posing for me as I struggled with learning to draw.

To Greg and Elizabeth for their inspiration.

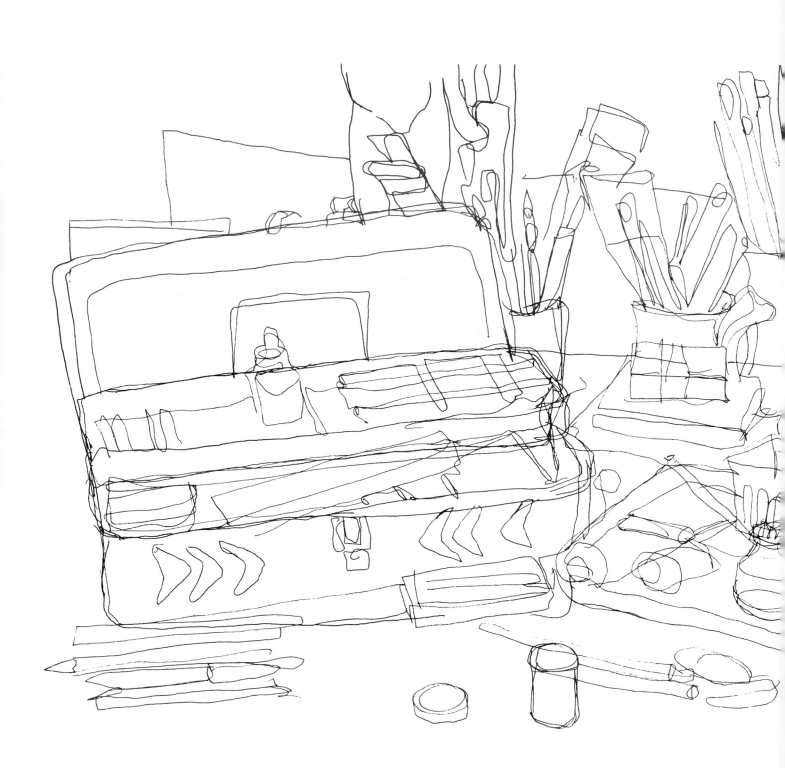

Contents

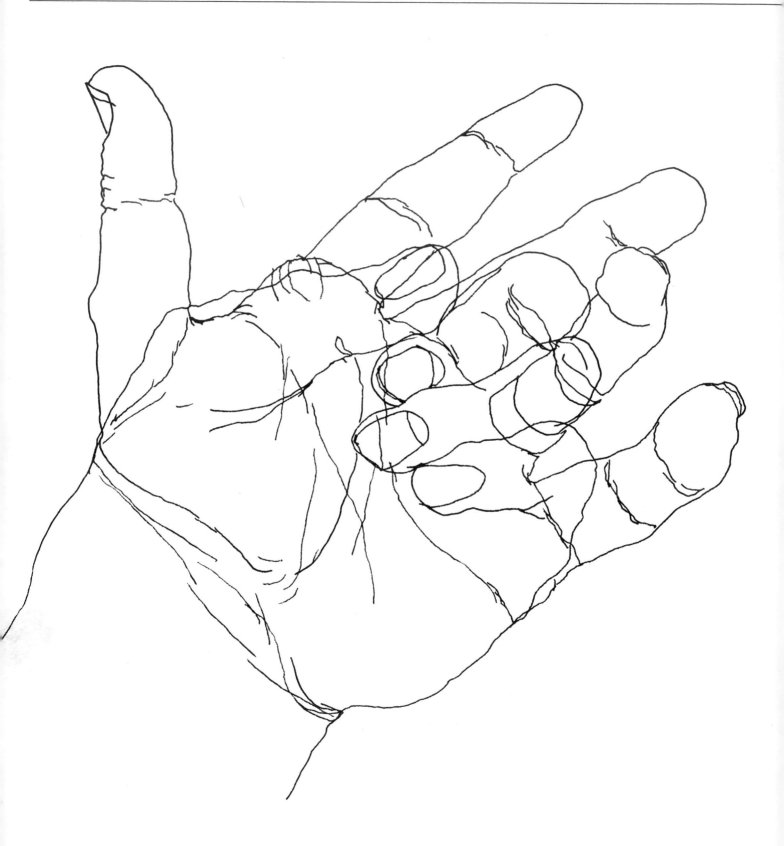

Introduction

There are many, many books on drawing. What makes this one different? First, it is designed to be practical and planned so that you can develop and improve your drawing skills using a series of carefully developed projects. Most of them are shown step by step so that nothing will be missed or taken for granted.

Second, this book is simple. It focuses on just a few themes, such as "seeing forms and drawing shapes." If you can understand and master these themes, your drawing will improve dramatically, guaranteed.

Third, it works. Combinations of specific exercises teach the simple themes to encourage results that are natural and inevitable. If you do the projects in this book, you *will* learn to draw better.

It has often been said that learning to draw is learning to see, but I think it is more a matter of learning *what to look for*. In the following pages, I will show you that you must learn to look at three-dimensional forms but see and draw them as two-dimensional shapes. Once you have reduced your subject to flat shapes, you must add the right lights and darks to create the illusion of weight and depth. It's really that simple.

Simple is not the same as easy, but therein lies the unending challenge and enjoyment of drawing.

There are three things that prevent many of us from learning to draw. Lack of talent is *not* one of them. A lack of time and persistence, and a surplus of fear can all frustrate your desire to learn how to draw better. However, it is fear of failure, of criticism, of wasting time, of finding out that you really don't have what it takes—that is the greatest impediment to learning how to draw.

If, out of fear, we convince ourselves that we cannot draw better, we will very likely prove that. Fortunately, the opposite is also true. If we convince ourselves that we *can* learn how to draw, and we take the time to practice persistently, we *will* learn.

In many drawing books, there are an enormous number of words. In this book, there are just enough to give you clear directions for the projects, with an explanation of the purpose of the exercise. You can't learn to draw by reading about it. You learn to draw only by drawing and more drawing. The purpose of this book is to get you drawing right away—having fun and improving from the start!

Chapter 1 Making Drawing Fun

Much has been written lately about learning to draw. It seems that, suddenly, everyone is discovering drawing. It's not surprising news (to me, anyway) that learning to draw is within the reach of the average person. And it *is* true—drawing is a teachable, learnable skill.

However, no one can make learning to draw effortless—any more than a good trail map will make a hike in the woods "easier."

Like any other skill you want to master, drawing requires *time* and *effort*. Even with the best guide, the best equipment and the best trail map available, you still have to put your own feet one in front of the other for hours to hike in the woods! Nevertheless, you don't have to stare grimly at the ground; you can whistle while you walk and look at the beauty around you. Like a good trail map, this book will make the "drawing" trail as clear and as scenic as possible.

Here's a simple example of how you can make drawing more fun: It will take a little more time and effort to select interesting and personally meaningful things to draw than it will to reach for whatever is handy—but it will make a huge difference. Why? Because if you're working from subject matter that means something to you, you will pay more attention to it, and you will be more alert and observant. As a consequence, you will put more into the drawing, and you will get more out of it.

We do *best* what we *like* to do. The more fun an activity is, the more willing we are to do it longer. The longer we do it, the better we get; the better we get, the more fun it becomes, so we want to put more time into it, and so on. Learning to draw should be an upward spiral of pleasure and accomplishment.

Twelve ways to make drawing fun

1. Set aside a special place just for your art activities.
Dedicating a space to your art makes it a little easier to dedicate yourself to its pursuit. You don't have to add a new wing to your house right away, either. Start with a table in the corner (away from the kids). Then expand. Your space needs to support your ability to spend time working, rather than make it a struggle.

2. Listen to music while you work.
Create an atmosphere that is conducive to concentration in your work place. Include a cassette or CD player in your area and listen to appropriate music. I suggest that you collect music you like rather than just switching on the radio. Your favorite music will bring pleasant associations to mind, and soon the music itself will help you get in the mood for a productive drawing session.

3. Collect fun objects to draw.
Your choice of subject matter is one of the most important aspects of learning to draw—more important than you may realize. Your ability to draw is directly related to how long and how well you practice. You won't practice long enough or well enough if you aren't interested in what you're drawing.

4. Reward yourself with fun materials.
Be an art materials junkie—but use what you acquire. Set up a system of rewards: Buy new materials to experiment with when you meet a goal, such as doing three more exercises. If you find that you are inhibited by a fear of wasting "precious" supplies, buy two of everything—one to "waste" through honest, fearless effort, and the other to treasure.

5. Use cheap materials where appropriate.
Most of the projects in this book do not require expensive materials. For instance, if you can find a source of discarded computer printouts, you will have a ready supply of paper that is perfect for contour and gesture drawing. Don't throw away paper that has a blank side that you can scribble on. Even old letters and junk mail can be recycled for your artistic development. You may be amazed at how liberating working on scrap paper can be. It gives you permission to let go.

6. Include drawing time in your routine.
I highly recommend that you make it a habit to draw during the same times each week. Once you get used to drawing, and it becomes a part of your routine, you will find it much easier to maintain a steady pace of improvement.

It's better to practice a half hour a day, three days a week, than to practice three hours, one day a week. Why? Drawing is like physical exer-

I have amassed a small collection of still life objects that I just love to draw. My collection alone constitutes a creative statement on my part.

Get a sketchbook and get into the habit of using it every day.

cise. Shorter sessions at evenly spaced intervals allow the mental muscles to strengthen, while too long practice sessions cause you to get tired or bored and to begin associating unpleasant feelings with drawing. Better to work for a short time than to suffer through a long session. Learning to draw is a long distance run, *not* a sprint. Be the tortoise, not the hare.

7. Draw a little every day. It is good to develop a daily drawing habit. Even if you draw only ten minutes a day, you will be astounded at the difference it makes. Just ten minutes a day of contour drawing will sharpen your skills in a surprisingly short time. Take a short drawing break, perhaps at lunchtime, breaktime or bedtime, and do a blind contour or a series of gesture studies. Or try doing it the first thing in the morning. My motto is "Never do *nothing* every day."

8. Get into the sketchbook habit. One way to work drawing into your daily schedule is to always have a sketchbook handy. Start with one that will fit into your pocket: a 4 × 6 inch (and an Ebony pencil). Then use it. Doodle, sketch and make gesture studies in it every day. Later, when the book is full, buy the next larger size. Soon, you will feel uncomfortable without a sketchbook under your arm. And you will gradually lose any self-consciousness about carrying it and using it.

9. Join a class or start your own. It's always easier to concentrate your efforts if you share the company of like-minded individuals. A class can be a source of inspiration and support as long as you don't compare and compete. It's best if you find a group that is near your own skill level. Check your local colleges and art institutions; many offer art classes that will be suitable.

10. Brag a little; show off a little. Don't be afraid to feel good about what you're doing. If you draw something you like, put it up on your wall or on your refrigerator so you can admire it. If others see it, you may find yourself receiving compliments. Drink them up! You'll find that most people will like your work more than you do, which reminds you that you're always going to be your own worst critic!

11. Give your drawings away as gifts. A lot of the projects and exercises in this book may result in remarkably interesting drawings, even though that isn't the main point. When you draw an "accidentally" unique and compelling image, consider giving it as a gift to someone who would appreciate it.

12. Learn to learn from each drawing. Study your drawings (and those of others) to learn how to do them better the next time. But don't become obsessed with how good or bad they are. Instead, analyze what you like in your drawings and try to do more of that in your next one. Periodically compare current work with your earlier efforts to check on the progress.

Interesting objects

Here are some suggestions for fun things to draw:
- *Toys, dolls and other childhood items*
- *Antiques of all kinds*
- *Musical instruments, especially old ones*
- *Tools, especially old-fashioned hand tools and kitchen utensils*
- *Small machines and mechanical objects like old typewriters, old cameras, telephones*
- *Memorabilia*
- *Plaster or ceramic statues*

Check the following places to find good stuff to draw:
- *Flea markets and antique stores*
- *Goodwill and thrift shops*
- *Your attic, basement or garage*
- *Plastercraft and ceramic shops*
- *Museum shops*
- *Craft shops*
- *The kids' toy box*

Feel good about what you're doing. Show off a little!

How to use this book

This book was designed to be used. However, you'll probably read a lot of it before you actually begin to work. That's fine. Peek ahead any time, or better yet, read it from cover to cover before you draw. When you feel the urge to draw, I suggest you begin near the beginning and work sequentially through the exercises. You may also pick whatever exercises or projects appeal to you, and do them in almost any order. You will still benefit. But if you want to get the most in the least amount of time, take them in order.

The book has been structured so that you can use it several ways. If you are new to drawing, I suggest you start with the first exercise on page 14, and simply do them in the order presented. Do each exercise once, then move on. Don't belabor any one study. Later, you can repeat the sequence, perhaps with different subject matter, and you will gain much more by doing them the second time with the knowledge of how the exercises all fit together.

If you already have some drawing experience, or you want to improve your paintings by improving your drawing skills, look at page 132 for a list of problems and specific exercises that will help correct them. You can use the chart as a self-diagnostic tool and the exercises as the "prescription" for the problems you identify.

Once you have determined which is the best approach to the exercises, read over the chapter's introductory material, study the examples, then follow the directions for the exercise. The materials recommended work best, and, if possible, I suggest you use what is listed.

Materials

Assemble a basic set of materials as follows. If you buy these all at once, you will have the materials you need to complete most of the exercises in this book, so you won't have lack of materials as an excuse for not drawing. Keep your materials neat and in one place.

These materials have been chosen because they are perfectly suited for teaching you the lesson of each project. Whenever possible I have also listed alternative materials where substitutions could be made.

The materials needed to complete the projects described in this book are not very expensive.

Luckily drawing is not an expensive pursuit. All you really need is a pencil and some paper. Later, when you have a good sense of the principles of drawing and a clearer commitment to making a valid artistic statement, you can indulge yourself with a multitude of varied, specialized and more expensive drawing materials.

One stick of soft (6B or 4B) graphite. A graphite stick is a 3-inch-long, 1/4-inch-square stick of "pencil lead." Buy the very softest you can find, at least 4B; 6B is best. Graphite sticks will be used for gesture scribble drawing when you need something that will glide smoothly over the paper. By the way, the higher the "B" number, the softer the lead; the higher the "H" number, the harder the lead.

Ebony pencil. An Ebony pencil is a brand of pencil with a thick, soft lead. It makes a very nice black line, and I like to use it for contour drawing when it has a good sharp point. For contour drawing, an ordinary No. 2 pencil will work, but a pencil with a soft lead is best. Hard-leaded pencils scratch the paper in an annoying way.

A 20 × 26-inch drawing board. You will need a 20 × 26-inch drawing board that is flat, smooth and stiff. You will be working on a rigid, unbending surface that doesn't give your drawings a texture. The best for our purposes is a piece of quarter-inch tempered Masonite that has rounded corners. It's lightweight, inexpensive and thin enough that you can use large clips to hold the paper in place, and it's large enough that an inch extends around all four sides of an 18 × 24-inch piece of paper, which is the largest required for the exercises. Go to a lumber or building supply house and ask them to cut it to size. Special Masonite drawing boards are available with a built-in clip and a convenient hole cut in for a handle. But these can be less versatile—sometimes the clip gets in the way, and the handle hole reduces the surface available for working. Or, you can cover the working surface of plywood with smooth cardstock such as railroad board or a portable drafting board, but both are heavy and cumbersome. They are also rather thick, making it difficult or impossible to use clips to hold the paper.

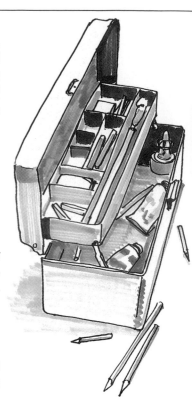

Cheap paper such as blank scrap paper or used computer printout paper. Fear of wasting your materials can subtly sabotage your efforts. A number of exercises in this book are designed to "loosen you up," but they can't be very effective if you're going to worry about wasting paper.

I heartily recommend you save scrap paper for quick studies and gesture drawings. Check the wastebasket next to the office copier! Scrap computer printout paper is ideal. Nowadays it's not that difficult to find a source of this paper. The 11 × 15-inch computer paper is just the right size for your scribble drawings.

Pad of fifty sheets of 18 × 24-inch newsprint. Called newsprint because it was once identical to the paper newspapers were printed on, newsprint used to be an inexpensive paper for drawing. Now it's no longer so inexpensive, but it's still the best surface for many of the exercises in this book. Newsprint has a soft, grainy texture and a creamy color. Because it's made from wood pulp, it's impermanent. Drawings on newsprint will yellow and become brittle in just three or four years. Its deterioration is hastened by exposure to sunlight. Therefore newsprint is not suitable for drawings you want to keep, but it is suitable for practicing many of the exercises in this book. Either smooth or rough newsprint can be used.

18 × 24-inch white drawing paper (cartridge paper). This is the closest thing to "generic" drawing paper. It is a grainy white paper with a slight tooth (grain or texture) that holds chalk and Charkole well. It is not expensive and will come in handy for many of the exercises in this book. It is sometimes called "cartridge" paper, because it was originally used to wrap the ball and powder charge for muskets in the nineteenth century.

18 × 24-inch gray charcoal paper. Charcoal paper is specifically manufactured for use with soft powdery materials such as charcoal and pastel. It has a distinctly patterned grain or texture on the paper, which catches and holds the powder. It comes in many colors, but you will need a medium gray (although dark or light gray will work fine). The very best charcoal paper, such as Canson Mi-Teintes can be very expensive and is not really necessary for the exercises. Buy the cheapest kind you can find.

Four large clips. These clips are large metal spring clamps that easily and quickly secure the edge of your paper to the drawing board. You must have at least two to hold the two top corners of your paper, but four, one for each corner, is best. Any large clip or fastener, such as a No. 4 "Boston" or "Bulldog" clip or a No. 100 Binder Clip, will work, but you should use something. Don't place a loose sheet on your board and hold it there with your free hand or elbow.

Charkole. Charkole is a type of soft black chalk made by Weber Costello. It is powdery and fine grained. Charkole makes a rich velvety black that is easy to blend with a fingertip or tissue; it also can be manipulated or removed readily with the erasers listed below. No other material can duplicate the qualities of Charkole; however, soft-compressed charcoal will work adequately.

One stick of soft white blackboard chalk. Since white chalk and Charkole can be blended on the paper to make a wide range of grays, we will use them to make value drawings in gray. Buy a box of ordinary children's blackboard chalk at your local discount or variety store. Avoid any hard or "dustless" chalks.

Plastic eraser. An eraser is not merely a device for making corrections. It can be used for creating many effects on the paper. Think of an eraser more as a positive tool than merely a thing for removing errors. You won't need an eraser for the early exercises in this book, because it is impossible to make a mistake if you follow the directions. When you do need an eraser, use a white plastic one, such as those made by Factis or Mars. These erasers have remarkable abilities to move or remove graphite or charcoal from paper. Often you can restore the paper's surface to nearly its original whiteness. A soft pink eraser such as a Pink Pearl will also work nearly as well.

Kneaded eraser. A kneaded eraser makes a good complement for either the plastic eraser or the Pink Pearl. A kneaded eraser must be pulled and worked like taffy before it can be used. The

warmth of your hands and the stretching and kneading activate its ability to absorb loose powder from a drawing. The kneaded eraser should be rolled over the paper first so it can pick up the most loose powder. Rubbing with the kneaded eraser can create little bits of eraser "noodles" and can grind the powder into the paper.

Bottle of black India drawing ink or black writing fluid.

Cotton-tipped swabs such as Q-Tips.

A ½-inch flat, soft (camel) bristled brush. The brush and cotton swabs will be used with the black ink for gesture drawing, value studies and wash drawings. Almost any medium-sized, soft-haired brush can be used. Wash the ink out of the brush after use.

One large black crayon or a soft black lithography crayon. Large crayons made for children are useful drawing tools. Only black is required for the projects in this book, but many of them could be done in a favorite color just for variety.

Cheap cardboard portfolio. Buy a large (approximately 30 × 24-inch) cardboard portfolio to store your drawings. Many of your drawings are not really supposed to be finished drawings. They are merely exercises for practice and experience. You will probably not want to keep all of them. Save and date a few just for a record and as a way to check on your progress.

Spray fixative. Spray the drawings done with charcoal, chalk, or other powdery materials with a fixative. Read and follow the directions on the can. In particular, spray lightly. Several coats are better than one heavy one. *Always* spray out of doors or in an area where fresh air is moving. Watch for the overspray, which will go all over the place if you're not careful.

A box for supplies. A fisherman's tackle box or mechanic's toolbox is a handy way to keep all of your drawing tools together. Some fancy boxes with many small compartments are made just for artists. Having one is part of the fun.

Apron or smock. Drawing can sometimes be a dirty job (but somebody has to do it, right?). Chalk and charcoal can be especially dirty. Wear old clothes or buy a cheap apron or smock to protect yourself. You can also use a towel over your lap to keep dust and eraser particles from depositing on your clothing.

A winning attitude

Learning to draw better is often a matter of maintaining the correct attitude. Winning the inner game is vital to your success. I think this aspect of learning to draw is often neglected, resulting in needless frustration and defeat.

Always keep in mind that drawing is a teachable, learnable skill. Learning to draw is just like learning to type, or drive a car, or any other similar task. Many of us have the idea that we need "talent" to be able to draw, and that if we don't have it, we might as well not try.

The fact is, almost all of us have the capacity to learn how to draw better, even if we don't have that mysterious thing called "talent." Because we know from experience that most people can learn to drive a car or type, we don't hear people saying "I sure wish I had the talent to drive," or "Too bad I wasn't born with the typing talent." The difference between our attitudes toward driving and typing and drawing is that we know what it really takes to learn how to drive or type: good instruction and lots of practice. Well, the same is true of drawing; all you need is good instruction and lots of practice.

The internal critic

The second thing to learn is to monitor and then ignore or turn off the internal critic that everyone has inside his head. It's the little voice that reminds you that your drawing is no good, that you have no talent, or that you will never get better, or that the next guy is a better artist. Without your conscious control the inner critic will chatter away, slowly demoralizing you and undermining your efforts.

As soon as you hear the first peep out of the internal critic, you must recognize it for what it is, and practice ignoring it. Acknowledge it by thinking, "I hear you," and then deny its message, "but I'm not listening!" If the voice says "This drawing is off to a bad start," say "But I

Drawing can be a dirty job.

will give it a good finish.'' Don't reach for a new piece of paper.

Practice focusing on your drawing and what it needs, rather than indulging in self-criticism. If the inner critic says, "This drawing isn't working," think, "What does my drawing need to make it work?" Rephrase each criticism so it refocuses your attention on seeking solutions to each problem. Keep it from getting personal.

Draw drawings—not conclusions—about yourself, your talent or abilities or about the next guy. The more you are focused on what you can do on the paper to make the drawing better and the less you focus on yourself, the better.

A word about failure

If you have the right attitude, it is simply impossible to fail. That is exactly right. No matter how a drawing turns out, you can still have a successful drawing session, if you were practicing the right habits. And that includes learning from your mistakes.

The people who learn anything well are the people who have the greatest tolerance for themselves as they make mistakes when they first start learning, and then don't give up. They for-

give themselves if they make a bad drawing, and then they go on. They are so focused on the goal of making the drawing they are working on right now that they don't have the time to think about how good or bad it is or even how good or bad they are as artists.

Let me tell you about Hal. He was one of the few people I have met who just didn't pay any attention to his inner critic. I don't even know if he had one. He came to my class with almost no experience but with a lot of desire. He had a goal. His first drawings were awful. They stayed awful for a long time. He once told me he thought they weren't very good, but then he immediately added "yet." He would ask for help when he drew, but he always had a very specific question like "How do I make this edge clearer or what can I do to make the values better?" He never said "Make my drawing better," or "You fix it." He just worked away, day after day. He thought it was fun, and he expressed pleasure and even amazement at even being able to make any sort of drawing at all. He really sensed the magic of making marks on the paper look like something. In time, he began creating very good drawings and went on to be a successful, exhibiting artist.

Learn to ignore your internal critic.

Chapter 2 Drawing and Seeing

Artists see the same world as everyone else, but artists are trained to *look* for different things—things that go unnoticed by nonartists. That's why it's sometimes said that artists see things differently. Artists look at the same world, but they are attentive to aspects of that world others ignore. Just *what* artists are looking for is the real secret of drawing.

The secret of drawing

It's a tired cliché, but learning to draw does involve learning to see. Drawing demands a whole new and exciting kind of vision.

Drawing is a process of looking at three-dimensional things and making a picture of them on a two-dimensional surface. To make drawings look "realistic"—that is, like what we see—we must learn how to correctly transcribe or project what we see onto a flat piece of paper.

So, the whole secret of drawing is:

You see three-dimensional *form*, but you have to draw it as two-dimensional *shape*. The remainder of this chapter, indeed much of this book, will be about explaining this secret completely. It is the key to unlocking your own ability to draw. If you can grasp and understand the idea of seeing form and drawing shape, the whole process of learning to draw will be a lot less mysterious.

Form and shape

Let's take a detailed look at this idea of seeing form and drawing shape.

First, whenever I use the word "form" I mean the real three-dimensional object, a thing in space that has height, width, depth and a volume that occupies a certain amount of space. Forms are what you see.

When I use the word "shape" I mean a flat two-dimensional geometric configuration that has only height and width. Shapes are what you draw.

Here are a few examples. If you look at a basketball, you see a spherical *form*, a round object that occupies space. If you want to make a drawing of the basketball on a flat piece of paper, what flat geometric *shape* do you draw? A circle of course. Looking at a round ball but drawing a circle is a simple example of seeing form (a sphere) and drawing a flat shape (a circle).

This is a sphere; it is form.

Here is a circle—it is the flat shape you must draw.

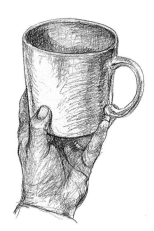

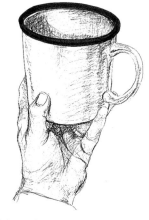

Here's a coffee cup. The opening is round, but when seen from the side, what shape is it? An oval or ellipse!

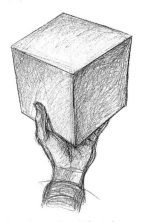

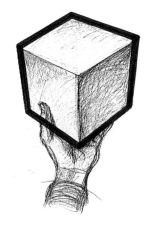

Here's a cube: What shape does this form have? It's a hexagon.

If you look directly at the round opening of a coffee cup, you can see it is circular. However if you look at the cup from the side at an angle, what flat shape would you draw to represent the appearance of the cup's mouth? An oval. Again, the circular opening of the cup is the form you see, the oval is the flat shape you draw.

Look at a cube with one of its corners tipped toward you. What shape would you draw to show this form? A hexagon.

These examples show us that we need to see "flatly" to draw a picture of three-dimensional form. So learning to draw is really a matter of first learning to see in terms of flat shapes. The artist is skilled at seeing forms in space and translating them into the correct flat shapes, which he then draws on the paper or canvas.

Therefore, to make a drawing of anything, we somehow have to convert our three-dimensional perception of the world into a flat picture on a flat (2-d) surface, be it canvas or paper. In other words, we have to eliminate one of the dimensions we see, that is, depth.

Seeing flatly

Here are ten ways we can learn to see things "flatly" and then draw them as flat shapes on paper.

1. Close one eye. Looking with one eye overcomes what I call the "handicap of stereoscopic vision" by reducing depth perception to a minimum, thus facilitating our ability to see flatly.

2. Look for the silhouette shape. The silhouette shape is the outside edge or outline of a form. A good example of the silhouette shape is a shadow cast by bright sunlight.

3. Notice the negative shapes. Negative shapes (sometimes called "negative space") is the shape of the space between and around things. An example is the triangular shape formed when you place your hand on your hip. That triangle is formed by your body and arms, the positive forms. Often if you draw the shapes of the space around something, you end up with a great drawing of the thing itself. Look at the shapes "trapped" by the legs and rungs of a chair. To draw the negative shapes between the positive forms of the chair is to draw the chair itself.

4. Relate things to the background. We are all probably familiar with the process of enlarging something by tracing a grid over it and then transferring it to a larger grid. An example of that is a pattern for a project in a craft magazine. A similar process can be used in drawing. If you think of all the lines in the background around your subject as a kind of irregular grid, you can use it to make a copy of your subject. Here we have a figure posed in front of a window that forms a handy grid we can use to make a copy on the paper. Drawing can sometimes almost be a form of mere copying.

Silhouette shape.

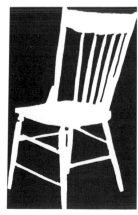
Notice the negative shapes.

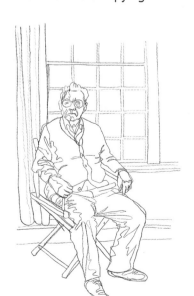
Relate the subject to the background.

Close one eye.

Use a measuring device.

5. Use a measuring device. You probably all have seen the cliché image of the artist closing one eye and sighting along his pencil or thumb held at arm's length. The artist is using his thumb or pencil device to compare sizes and check for alignments.

Using a pencil as a measuring device in this way helps you see flatly by enabling you to compare lengths and sizes. For instance, if you hold up a pencil at arm's length and close one eye as you line its tip up with your model's head, you can see where the chin lines up below it on the shaft. Perhaps it is a point about one inch down on the pencil. That is the apparent length of the model's head from your vantage point. Put your thumb there to mark it and move the pencil to line it up with the model's shoulder, and you can see if the distance from the shoulder to the elbow is a little bit longer or shorter than the length of the head. That's information you can use to make your drawing accurate.

6. Look for alignments. Always look for hidden alignments in your subjects. See how various parts or points line up or form geometric patterns. If you're drawing a figure, compare where body landmarks line up with each other. For instance, check to see where the shoulders line up with the elbows. Look at how the white stars are placed on this figure, like the constellation of stars that the ancient Greeks identified with the gods. If you can correctly copy the geometric pattern that those stars form, you will make a more accurate drawing. In this pose, the stars on the hands and elbows form a straight horizontal line.

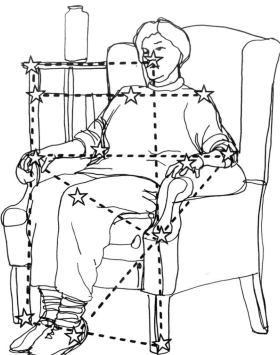

Look for alignments.

7. Look for a larger arrangement, not individual components. Instead of looking at all the individual items, look for the larger configuration or overall shape they form together. This calls for looking in a more comprehensive manner, stepping back, as it were, to see how separate things can be seen as a bigger shape.

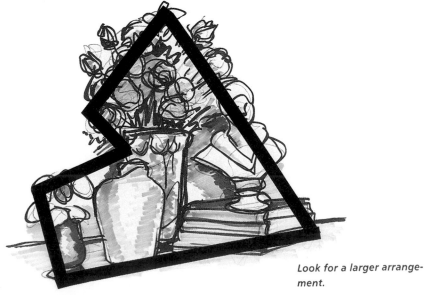

Look for a larger arrangement.

8. *Use a viewfinder.* Make a viewfinder as shown from two "L's" of cardboard and clip them together to create a small window. Use the viewer to frame your subject and notice how it relates to the edges. Notice the shapes that are "trapped" around your subject. By faithfully recording these shapes, you can make your drawing look like what you see.

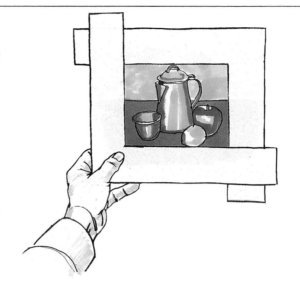

Use a viewfinder.

9. *Map the shapes.* Think of how all the shapes that you can identify interlock like the borders of countries on a map, or like jigsaw puzzle pieces. Draw lines around each shape, noticing how drawing one shape begins to establish all the shapes around it. Notice how edges, color changes, shadows and any other linear demarcation form a pattern of interlocking shapes and draw them as such.

10. *Think shapes as you draw.* As you are working on a drawing, get into the habit of thinking about everything in terms of shapes. Use shape words as you draw, not the names of things in your mental monologue. Tell yourself, "Now the triangle shape of the foot is at the bottom of the long rectangle of the leg, lined up below the round knee, trapping a kind of keyshape between it and the chair leg." Describe everything in terms of flat shapes. Use key words like circle, angle, square, triangle and so on.

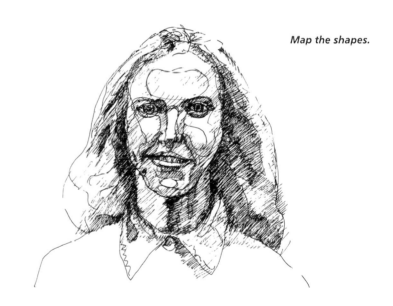

Map the shapes.

Think shapes as you draw.

Right and left brain

Several artists, educators and researchers, most notably Betty Edwards in her book *Drawing on the Right Side of the Brain*, talk about how the brain works and how an understanding of the brain's functions can help you learn to draw better by seeing flatly.

Their theories are based on the discovery that the brain is divided into two halves or hemispheres, the right and left, with each half having its own distinct specialties. Through medical research, brain scientists identified what each side of the brain does best and came up with a contrasting set of qualities.

The left side of the brain uses words to name and identify things. It is verbal and nominal, that is, it likes to use *words* to *name* things. The left side also likes numbers and numbering.

The left side of the brain has a good sense of time and is very comfortable with putting numbers to time, like "three forty-five." It can track the passage of time, and it can order things sequentially.

Numbers, words and time are all arranged in lines. We speak of the number line, time lines, and a line of text. Words, clocks and numbers are ways of arranging information into nice, neat lines that can be understood piece by piece.

Since the left side of the brain prefers to deal with small packets of information like words, seconds and numbers, it is the side that also likes to analyze things. It's the left side that can take things apart and reduce them to pieces to understand them.

Using reasoning and logic is also a left-brain specialty. The left side of the brain can line up reasons and facts, analyze them and come to conclusions. Dealing with abstract concepts, like goodness and truth, are left-brain functions as well.

In sum, the left side of the brain is verbal, temporal, digital, analytic, rational and abstract.

In contrast, the right side of the brain does not use words or numbers to understand the world. It is a lousy timekeeper. Instead of taking things apart, the right side of the brain puts things together to see larger patterns. It relates parts to the whole and arranges things spatially rather than in lines. It is also intuitive, deriving conclusions unconsciously. The right side of the

brain sees how unrelated things are similar, and it enjoys analogy and metaphor.

Notice that there is a general and opposing correspondence between the functions of each side; they can almost be arranged into symmetrical pairs.

We tend to favor the left side of the brain for normal everyday living in our society. Our educational systems stress the delivery of information in a verbal and linear way. We read words arranged in a long *line* of discrete bits of information. Even a computer—the very model, albeit mechanical, of the human brain—is really a model that works like the left side of the brain. We process information with words and symbols. We scan the world for the names of things to negotiate our way around. For most of us, the left side of the brain is dominant. We just don't rely on or even equally value the functions of the right side.

The left side of the brain requires different information to work with than the right. To supply this information, the eyes need to adopt habits of seeing to scan for information relevant to the left-brain processes. This scanning consists of a momentary, cursory glance for a few key identifying features. Once the names of objects seen

have been derived, the left side of the brain is satisfied. It is seeing for knowing.

The left side looks for identifying features for categorization. It needs just enough to quickly figure out what something is and how it fits into the brain's already formed notion of that class of things. It ignores or has difficulty dealing with any anomalies or variations or details, and neither cares nor remembers them. It needs to be able to analyze or generalize and process data.

What the left side of the brain needs is not particularly interesting to the right side, nor does it turn out to be useful information for drawing. In fact, the left side of the brain supplies information that is actually counterproductive to the act of drawing.

However, the right side of the brain supplies information that *is* immediately useful to drawing. To make a picture that *looks* like what is seen requires the kind of information that is the right brain's specialty.

The different ways the two sides of the brain look and see could be summarized as left-brain scanning and right-brain scrutiny or probing.

The right side looks for the shape, size and detail of things. It can immerse itself in these things, and because it is a lousy timekeeper, lose a sense of time. Often artists, thinkers, describe being lost in their work or losing a self-consciousness while they work. And that is due to them being in a very strong right-brained mode, with little jabber from the left telling them what time it is and to get on with it.

The most important skill or ability of the right side of the brain that is of interest to us as artists and draftsmen is the ability to see things as a whole and yet pay attention to detail.

The right brain can see the big picture and how its elements form an integrated whole. It can also focus on the particular detail — the specificity of things. It can do both by seeing flatly — what I consider the greatest of the right brain's specialties.

The following projects are exercises in *seeing*, rather than drawing per se. They will develop your awareness of the flat shapes you must draw when you see form. All of them entail some type of *copying*. Copying is perhaps the most important skill for drawing what you see. When you are drawing what you see, you are actually ''copying'' the flat shapes that you can distinguish as you examine your subject.

Right brain

- *Nonverbal: Does not use words to process reality*
- *Synthetic: Puts things together for understanding*
- *Analogical: Sees how things are similar; analogy and metaphor*
- *Nontemporal: Does not order things by time or sequence*
- *Spatial: Relates things to their parts and to the whole; arranges in space*
- *Intuitive: Conclusions arrived unconsciously*
- *Holistic: Sees whole patterns and relationships*

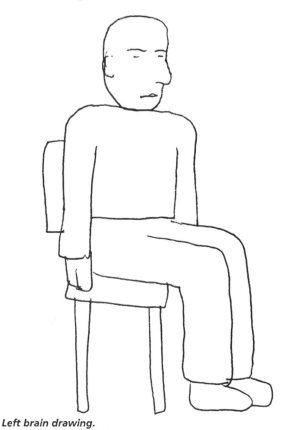

Left brain drawing.

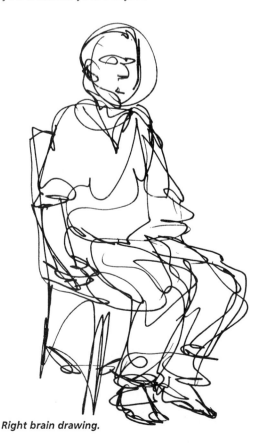

Right brain drawing.

These two figures represent the different ways two sides of the brain ''picture'' things: The left side of the brain relies on what it knows and often resorts to stylized or symbolic images; the right side relies on information about shapes it actually sees.

Mirror Image Drawing

Materials
- *Ordinary No. 2 pencil or Ebony pencil*
- *White paper; letter size, blank scrap paper is fine*

Time needed: *Three minutes for each*

This exercise, inspired by Betty Edwards's *Drawing on the Right Side of the Brain*, is a good one to begin the process of thinking in terms of shapes, instead of names. Artists must train themselves to "*see*" for more information than merely the name or identity of things. They must see shapes and relationships that nonartists do not look for.

Seeing as an artist requires using those faculties that the right side of the brain excels in: seeing wholes and determining spatial relationships. Words and names, the tools of the left side of the brain, are not only useless, they're actually impediments to seeing this way.

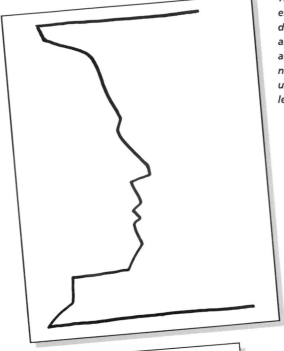

There are two parts to this exercise. First, make a line drawing of a face in profile as shown. It need not be an exact copy. As you do, name the parts of the figure as you draw it. This is a left-brain activity.

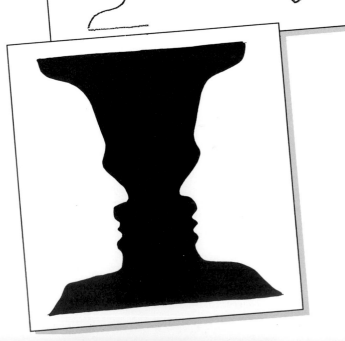

Comments
The shape that is created between the mirrored lines can be seen as a positive shape—a vase—or as background space between two facial profiles side by side. In other words, it can be seen as object or space. This is an example of "figure-ground" ambiguity.

Then, make a mirror image of the drawing, completing a shape between that resembles a vase. Make the mirrored image as close to the original as possible.

Notice as you do how you process the information to make a correct reflection. Instead of relying on words and names, you need to think about the size, direction and length of the lines you are mirroring. Thinking in this way is a right-brain activity. Words only get in the way. After you finish, try it again.

Upside-Down Drawing

Materials

■ *Ordinary No. 2 pencil or Ebony pencil*
■ *White paper; letter size, blank scrap paper is fine*
Time needed: *Three minutes for each*

Simply make the best copy you can of the drawing shown here, upside down as you see it. Don't turn the book upside down or copy it right side up. Work carefully and slowly. Include all the details.

As in the previous exercise, this one will encourage you to "think like an artist," using the right side of your brain to draw shapes and relationships, rather than the left side to name names.

Notice how you interpret the information given in the upside-down drawing. You are most likely thinking in terms like, "This line is about this long, and it is going in this direction. It meets that line at an angle like this, and turns to go in that direction," and so on.

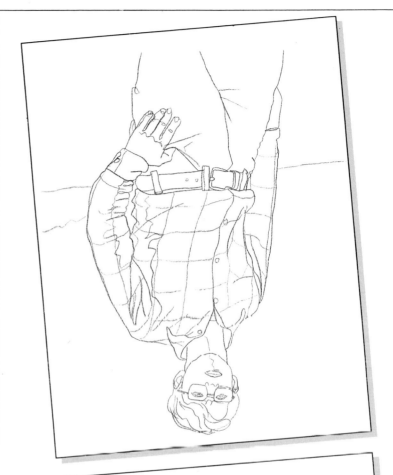

Comment

Turning a picture upside down makes it difficult for the left side of the brain to interfere with the right side's ability to do what it does best. As the left side struggles to identify and name pieces, the right side proceeds to process visual information in terms of lines, shapes, angles, lengths and directions.

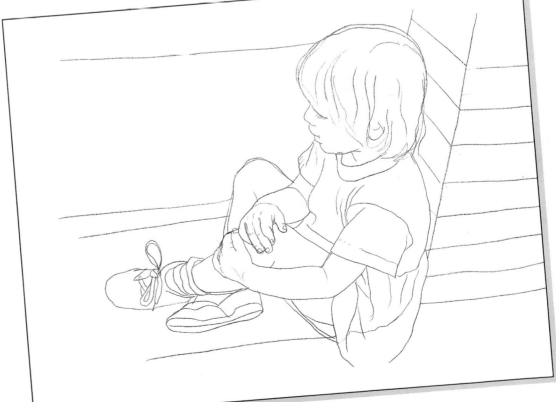

Copy this drawing twice, once as you see it, and again, turning it upside down. Compare the two drawings. Which one is more accurate?

Tracing Shapes on Photographs

Materials
■ *Ordinary No. 2 pencil or Ebony pencil*
Time needed: *About two minutes for each drawing*

In this exercise, you are simply going to trace the shapes you can find on a photograph with a dark pen, pencil or marker.

A photograph is an image that has been mechanically "flattened" by the photographic process. If you have little or no drawing experience, this will be your first opportunity to notice how the eye automatically interprets the flat shapes (and the lights and darks) of a photograph as forms corresponding to the volumes of the real objects.

Using a pen, pencil, marker or any other drawing instrument that makes a dark mark, trace around the shapes on the photograph above. If you do not want to draw in the book, make a photocopy or use tracing paper.

Here is another photograph to trace. Notice as you do, how the shapes interlock like a jigsaw puzzle. Notice also how some shapes, when traced, look oddly unfamiliar or unexpected.

Find other photographs in old magazines and trace the shapes you can see on them. Find at least one landscape, interior and figure to trace. You can do this in your spare moments as a form of doodling.

Trace the shapes right on the photograph.

Mapping

Materials
- *Ordinary No. 2 pencil or Ebony pencil*
- *White paper; letter size, blank scrap paper is fine*

Time needed: *About three minutes each*

In this project, instead of tracing on the photograph, make a "map" of the shapes in the photographs on a separate piece of paper. Your drawing will vaguely resemble a paint by number project.

 Once again, let the right side of your brain detect the interlocking shapes in the image. Ignore the left side of your brain's habitual naming.

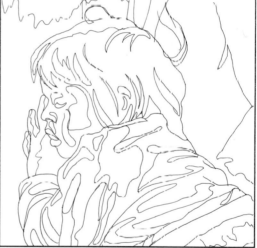

Make a "map" of the shapes in the photographs on a separate piece of paper.

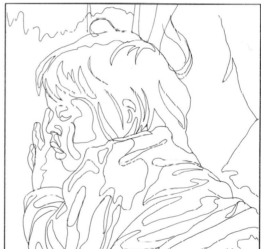

Here are some practice photographs. Find other photographs in magazines and map their shapes.

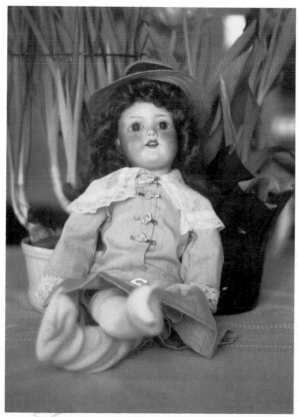

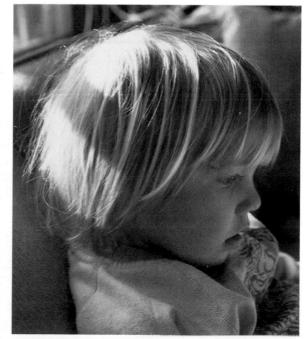

Copying With Grids

Materials

■ *Ebony pencil*
Time needed: *About three minutes each*

Copying can be a great way to learn. In fact, it once was a very important part of artists' training. Many famous artists developed their skills by going to museums and copying masterworks. Many artists' apprentices mastered the craft of painting by years of copying and imitating their masters.

Using a grid to copy is a good way to look at a picture and ignore its identity and analyze it in terms of flat shapes. It is excellent practice for drawing from life.

Here is a series of gridded drawings and photographs. Next to them are matching grids slightly enlarged. Copy the shapes of each gridded drawing on the left onto the grid on the right.

The first few should be relatively simple to do because the squares of the grids are small. As you progress, the squares become larger, which will engage the right side of the brain in judging lengths and identifying shapes.

This is a surprisingly instructive project, and despite its apparent simplicity, is not all that easy to do.

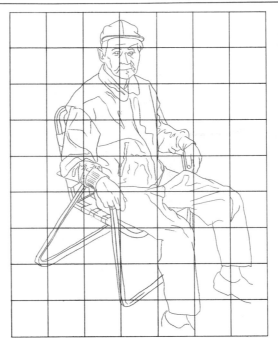

Copy the shapes of the gridded drawing on the left onto the grid below.

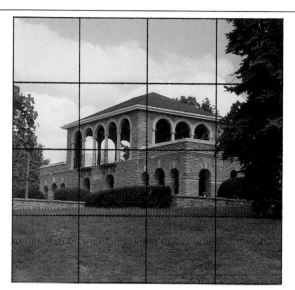

As you copy the shapes of gridded drawing onto the grid, notice how you process information about shape, length and direction.

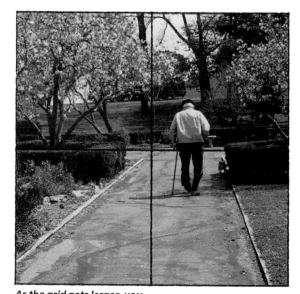

As the grid gets larger, you must rely on relationships among the lines of drawing themselves rather than with the grid. Ultimately, you can dispense with the grid altogether.

Negative Shape Puzzle

Negative shapes are the spaces you can see around objects. If you can accurately draw the shape of the space around solid forms, you will also be making an accurate drawing of the shape of the thing itself. Sometimes it's easier to see the exact shape of the negative space than the positive form, perhaps because the left side of the brain cannot readily place a name on that space. Here are some exercises, games really, to help you understand the importance of negative shapes in our efforts to ''see flatly.''

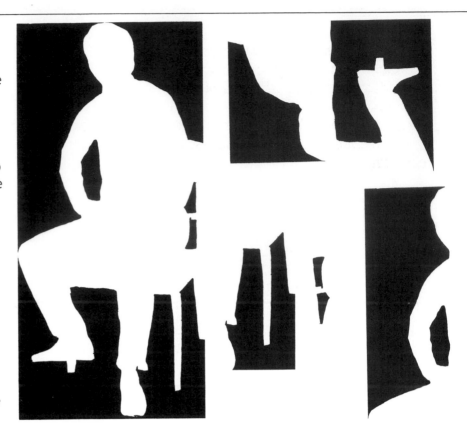

On the right is a white fig-ure on a black back-ground. Next to it are the shapes created by the space around the figure and the outside edge of the background. Can you identify where each of these shapes belong in the complete picture?

Using strips of paper, frame a photograph of an object or figure so its edges are tangent to the inside of the window cre-ated by the strips. Copy the shapes of the space around the figure, concen-trating on their exact size and configuration and their relationship to each other. Notice how the careful transcription of these shapes defines an accurate image of the posi-tive shape, the object it-self. You are drawing something by drawing the ''nothing'' around it!

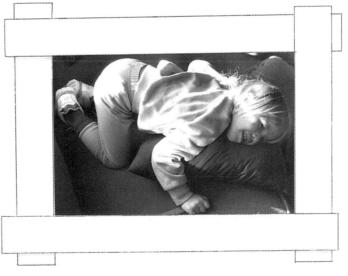

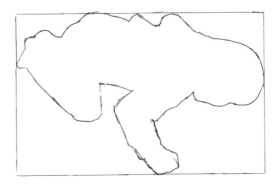

Negative Shapes in Viewfinder

Materials
Homemade cardboard viewfinder
- *Ordinary No. 2 pencil or Ebony pencil*
- *White paper; letter size, blank scrap paper is fine*

Time needed: *Ten minutes to make the viewfinder; about five minutes for each drawing*

A viewfinder is a small cardboard frame through which you will look as an aid to identifying the negative spaces around an object. Viewfinders are time-honored devices for helping artists see things as flat shapes.

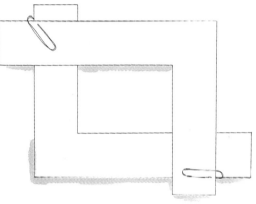

To make a viewfinder, you will need to make two "L's" of the dimensions shown, out of thin cardboard. Use paper clips to hold the "L's" together to make an adjustable window. The opening should be about the same proportions as the paper you are drawing on, approximately 5 × 7 inches.

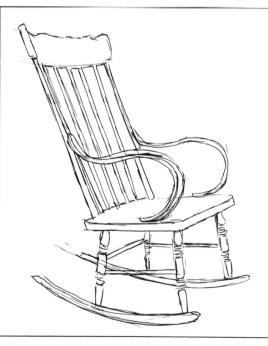

Trace the opening onto a piece of paper. Hold up the viewfinder and "frame" an object such as a piece of furniture so its outside edges appear to just touch the inside edges of the frame.

Concentrate on seeing the shapes of the space trapped by the outside edge of the object and the inside shape of the opening. Carefully copy as best you can the shapes that you see around the object on your paper. Don't try to draw the object itself.

If you draw all the shapes of the negative spaces around solid form, such as this chair, you will create an accurate drawing of the chair itself.

Draw on a Window

Materials

■ *Crayon, grease pencil, china marker or a water-soluble marker*
Time needed: *Ten minutes*

Think of your drawing surface as a transparent screen through which you could see what you are drawing. The drawing surface corresponds to what artists call "the picture plane." Lines drawn from the top, bottom, and other points of the model to the eye form a kind of cone that is intersected by the picture plane. If each line that intersects the plane made a mark, all the marks together would form a picture of the object on the screen, as shown below.

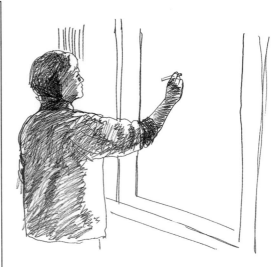

Stand about arm's length from a window and take a crayon or grease pencil and make a tracing on the glass of what you see through the glass. Keep your head stationary and close one eye. You will have to focus your eyes back and forth from the glass to the objects beyond the window.

Use a soft cloth and window cleaner to remove your drawing.

You can also draw on a piece of transparent Plexiglas taped to a window or mounted on an easel.

The drawing you did on the glass corresponds to the points on the picture plane where it is intersected by lines drawn from the subject to your eye. Drawing on glass clearly shows how three-dimensional forms must be reduced to flat shapes if you want to make an accurate drawing.

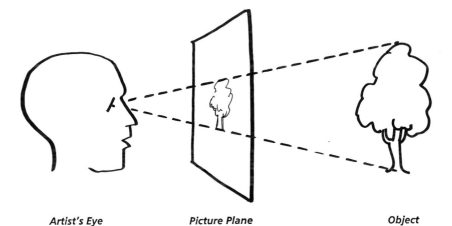

Artist's Eye Picture Plane Object

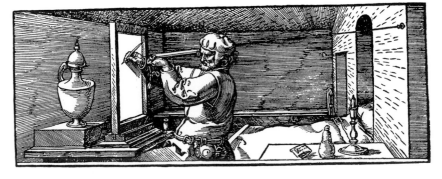

This print by Albrecht Dürer shows how artists have experimented with other mechanical devices that transferred forms into shapes like drawing on glass does. Of course, the ultimate mechanical device for this process is the camera.

Draw on a Mirror

Materials

- *Wall mirror*
- *Crayon, grease pencil or china marker*

Time needed: *Ten minutes*

After drawing on the window, trace your reflection seen in a wall mirror with a crayon, grease pencil or china marker. Trace any lines or other objects you can see in the reflection. The marks can be easily removed with a paper towel and glass cleaner.

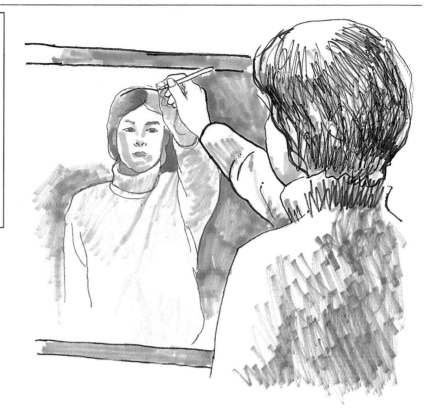

Trace your reflection on the surface of a mirror.

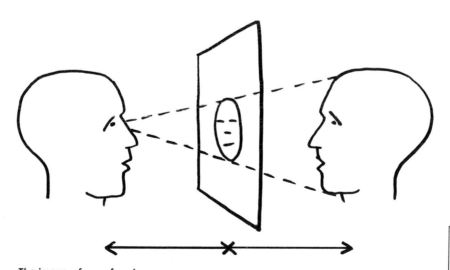

The image of your face in the mirror will be the same apparent size as if you were looking at yourself from twice the distance between you and the mirror.

Comments

You will discover two interesting things about the image in the mirror. First, you might be surprised at how small your reflection really is. In fact, if you stand three feet away from the mirror, the image actually appears as if you were looking at your double from six feet.

Chapter 3 Contour

In the previous chapter, we learned how to *see* three-dimensional forms as two-dimensional flat shapes. Now we need to translate our new "seeing" ability into drawing.

The first exercise in our quest to learn how to draw *flatly* is called contour drawing. A contour is defined as any edge or line you can see on, in or around a thing or shape. The most basic contour is the outside edge. In addition, anything on an object that appears as a line such as a fold, crease, wrinkle, marking or abrupt change in color is a contour.

your hand so it traces the path of your eye along the contour lines. Blind contour means you are making an exact record of what you see *as* you see it.

Pretend that you are *touching* what you are seeing with your pencil. Imagine that the pencil isn't on the paper at all, but is actually touching the point where your eyes are focused. When drawing a blind or pure contour, your hand is like a seismograph pen recording every movement of your eye. Let your sense of touch guide your eye and hand. You could say that contour

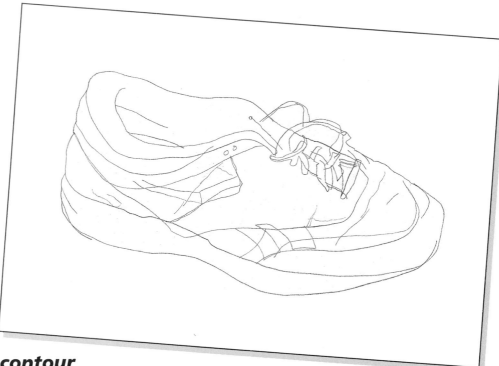

Any line you could touch with your pencil can be included in a contour drawing.

Blind contour

The essence of contour drawing is drawing while keeping your eyes on the thing you are drawing, and not on the paper. Because you can't see what is happening on the paper as you draw, this way of drawing is usually called "blind contour," or "pure contour." The general procedure is simple. Let's say you're drawing an old shoe. Pick a point on the outside silhouette edge, put your pencil on your drawing paper, then have your eyes follow along the edge of the shoe while your pencil moves slowly on the paper at the same time.

As your eyes move along the shoe's edge, move the pencil on the paper following the same path as your eyes. If your eyes go up, so does your pencil; if your eyes go down, so does your pencil. You want to coordinate your eyes with

drawing is touching with the eyes and seeing with the hand.

Contour drawing is touching with the eyes and seeing with the hand

Imagine that you have in front of you a pure white marble statue. And you have in your hand a pencil. Starting at the top of the statue, you make a fine pencil mark down the side of the statue. Your hands would feel every undulation and change in the form of the statue as you trace along its surface. When you do a contour drawing of that statue, your pencil will move, not on the statue itself, but on the paper, and the sensation should be almost the same.

Maintain the sensation that you are touching what you are looking at as you draw.

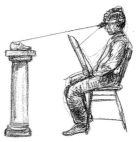

The path of your pencil on the paper follows the path of the eye along the contour lines.

When you're doing contour drawing, imagine that you have a laser gun attached to the middle of your forehead that projects two laser beams, one directly at your subject and another at your paper. Pretend the beam could burn a line on your paper. If you moved your head as your eyes followed the contour, both beams would move at the same time. The beam directed on the paper would register the movement of eyes as you directed the other beam along the contours.

Why blind contour?

Why draw without looking at the paper? When most untrained individuals try to draw, they look up at their subjects and then try to memorize what they see for a few brief moments, then they look down at their paper and try to draw what they saw *from memory*! They are actually not drawing what they see, but what they remember seeing.

Unfortunately, there are several problems with this way of drawing. First, we don't know how to really see what we are looking at. As we discussed in Chapter Two, the left side of the brain scans the world for different information than the right. It looks for information that is not very useful for drawing. Most of us aren't trained to really *see* much less remember what the right side looks for.

Second, our visual memory is notoriously bad—the human brain just doesn't record what we see with the same detail and fidelity as we remember what we hear or smell. Perhaps this is a good thing considering just how much information our eyes are constantly relaying to the brain.

Finally, when we do look down at the paper to draw what we saw poorly in the first place and can't remember in the second, we have no frame of reference for scale and proportion. No wonder so many people think that drawing is hopelessly difficult!

However, contour drawing, especially blind contour, short circuits all of these difficulties. When you are drawing a blind contour correctly, your eyes are focused on one point at a time. You are not giving the left side of your brain the information it needs to name or identify your subject. Since you are drawing what you see *as* you see it, you don't have the opportunity to forget what

it looks like. Finally, because you're relying on a sensation of touch to guide you, you don't need any reference to size or proportion.

When you are doing a "blind" contour, the urge to look down will be a hard habit to break at first. Not only is it almost automatic, but the curiosity to see what your drawing looks like will also be strong. Simply stop the pencil when you do look, and gently remind yourself to keep your eyes on the subject. Soon you will become so absorbed in the process of seeing with your pencil and touching with your eyes, that you will soon forget about what is happening on the paper.

It's possible that in the course of a contour drawing, the pencil may slip off the edge of the paper. If that happens, just pick up the pencil, find the point on the contour where it left the paper, and resume drawing. You can look down at your paper any time you want, just stop moving the pencil when your eyes leave the subject matter. If you **see** a moving pencil, you're doing a memory drawing!

If contour drawing is done conscientiously, by focusing on the sense of touch, it is almost impossible to make a "bad" contour drawing, no matter what the resulting image looks like. Contour drawing is *not* about making a good-looking drawing.

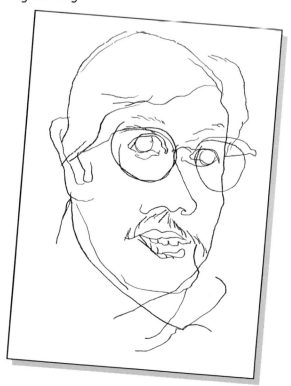

Your first contour drawing may not look at all like your subject matter and still be a very good contour drawing.

Subject matter

The selection of your subject matter for contour can make a real difference in the quality of the experience as well. Don't pick just anything. It works best if you take a little time to select objects that have some meaning or significance for you.

For instance, select five things that remind you of your childhood such as a doll, a toy train or baseball glove. Or select objects that are related to your favorite pastime such as skates, gloves or a wool hat. Collect those things and draw them one at a time and then together in a still life arrangement.

Silhouette Contour

Materials

- *Ebony pencil, sharpened to a point*
- *One sheet of 18" × 24" newsprint*

Time needed: *Two to five minutes each, depending on the complexity of the subject*

Your first experience with contour drawing will be very simple so you can concentrate on *how* you are doing it. In this introductory exercise, you're going to draw only the outside edge of the object or model. You will begin on a point on the silhouette edge and draw all around the object back to your starting point, without looking at your paper.

First, select an interesting object. Put it on a table or stand in front of you. Sit on a comfortable straight chair. Rest your drawing board on the back of another chair in front of you. You should be able to see the whole object over the board. The bottom of the board should rest on your lap. You can also use an easel, but turn it so you can see around it. Hold the pencil as if you were writing, but use your shoulder more than your wrist as you draw. Don't grip the pencil tightly.

 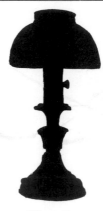

Object　　　*Silhouette*　　　*Silhouette Contour*

Place your pencil near the top center of the paper, and focus your gaze on a point near the top of your subject on the outside edge. Begin moving your pencil on the paper as you follow along the contour line with your eye. Draw slowly.

As you draw, move your eye and your hand at the same rate. Do not draw unless you have the absolute conviction that the pencil is touching the point you are looking at. Do not draw while looking at the paper.

Comments

By concentrating on the outside edge only, you are reducing the three-dimensional form of your subject matter into a flat shape on your paper. This is the first step in training your eyes to see things flatly so you can make a drawing that looks three dimensional.

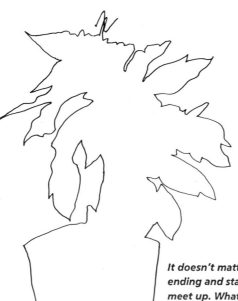

It doesn't matter if your ending and starting points meet up. What matters is the experience of touching your object with your eyes as you move the pencil on the paper.

Internal Contour

Materials

- One stick of soft (6B or 4B) graphite
- One sheet of 18" × 24" newsprint

Time needed: *Five or more minutes each depending on the complexity of your subject. Don't rush contour; quality counts more than quantity.*

Perhaps as you did the previous exercise, you saw how a contour line could be followed inside the silhouette shape. You may have noticed how you had to avoid turning inside the silhouette shape to keep following the outside edge.

The contour lines that are visible inside the silhouette edge are called the *internal* contour lines. Follow these lines and often they seem to disappear somewhere within the boundaries of the outside edge.

Try drawing the same objects you used for the previous exercise, only this time go back and include all the internal contours after you finish the outside contour.

In the remaining contour exercises, draw both the outside edge and the internal contour lines. Let your pencil follow them as they turn into the larger contour shapes. Ease up on the pencil on the paper as they trail off.

The contour lines that are visible inside the silhouette edge are called the internal contour lines.

1

Begin by drawing the external (silhouette) contour shape as you did in the previous exercise.

2

Begin drawing the internal contour lines that touch the outside edge. Start each line by placing your pencil on the outside where it turns into the interior of the larger shape and follow it with your eyes as your pencil moves on the paper.

3

Continue drawing the internal contour lines carefully and slowly. Draw only when you are convinced your eyes and hand are working together.

4

The finished contour drawing with all the internal contour lines.

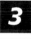

Contour of Your Hand

Materials
- Ebony pencil
- One sheet of 18" × 24" newsprint

Time needed: Three to five minutes each

Pardon the pun, but one of the handiest objects to draw is your own hand. Do a blind contour of your hand resting comfortably near your drawing board and draw all the wrinkles and folds. Hands are not as difficult to draw as you might think. Most students have trouble drawing hands because they have never really taken a good hard look at one! The best way to learn to draw them is to draw a lot of them. Luckily, it's very convenient; a good subject is always just an arm's length away!

Draw your hand in as many positions as you can comfortably hold for the three to five minutes it takes to do a blind contour. If you get bored drawing your left hand (if you're right-handed) try switching hands. Draw with your opposite hand while looking at the hand you usually draw with.

1

Begin by resting your hand on or near your drawing board. Make sure your paper is securely fastened to your board, because you won't have a hand free to hold it. Draw the outside edge first, all around your hand, while not looking at your paper.

2

Draw all the interior contour lines, redrawing over any of the perimeter contours if necessary. Draw all the wrinkles and lines you can see.

3

Work slowly, keeping you eye on your hand, not on the paper. Only draw when you have the conviction that you are actually touching the point on your hand where your eye is focused.

Comment

For an interesting variation, after you have completed your drawing, move a finger or two. Extend it or bend it into a new position, and then draw it again. This not only makes for an interesting drawing, it also can reveal some insight into the way the hand and fingers are structured and how they operate.

Contour of a Simple Object

Materials
- One stick of soft (6B or 4B) graphite
- One sheet of 18" × 24" newsprint

Time needed: Ten to fifteen minutes each

After several drawings of your hand, draw an assortment of small objects. My favorite things to draw are toys. Some are toys I played with as a child. Others are toys my stepson outgrew or that I snuck out of his toy box and never returned. Perhaps it's just the associations that linger with the toys or because toys are just plain neat!

1

Draw the outside edge of the object, creating an image of the flat shape of the object as revealed by its silhouette. Draw slowly and carefully, keeping your eye on the edge.

2

Now draw the internal contour lines. Start each line at the outside edge and draw into the shape. Only draw when you feel as if your pencil is touching the point that you're looking at.

3

You may look down at your drawing whenever you start a line, but you shouldn't see a moving pencil.

4

Often contour drawings have an unexpected charm about them, perhaps because there is a kind of visual honesty about the process.

Draw slowly

A word here about patience. It comes as a very pleasant surprise to many people that just taking the time to look closely and patiently, as in contour drawing, is all it takes to do a drawing that is better than they ever thought possible.

To develop this ability to concentrate, you should try to draw as slowly as you comfortably can while seeing as much as you can. The more you can see, the slower you will draw; the slower you draw, the more time you will have to see. In the beginning it is better to draw too slow than too fast, as your ability to really see what you're looking at develops with practice.

Contour drawing requires attention but not tension.

Outdoor Contour

Materials

- *Ebony pencil*
- *One sheet of 18" × 24" newsprint*

Time needed: *About ten to thirty minutes*

Contour drawing is a technique that can be applied to any subject. Don't limit or confine yourself to things that are small or close at hand or inside. In this exercise, do a contour drawing of something outdoors. It can be a "landscape" or a "close-up" of something outside.

One of the great things about contour is the opportunity to see things in a new way. Select a view of a scene that you see everyday, such as a view out your window, and imagine that you have never seen it before. Look at it as if it were a new vista; imagine what it would look like to a stranger, or even a visitor from another planet.

If the weather is nice, take your drawing board outside and draw in your backyard or from your front porch. You can also draw in a park or some other public spot. In inclement weather you could do an outdoor contour from the comfort of your home by setting up your drawing board by a window, or you can work from the front seat of a car.

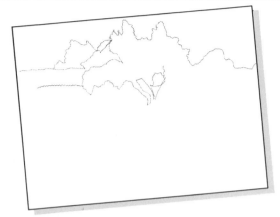

1

Draw one line at a time, working slowly and carefully. Don't be overwhelmed by detail. The horizontal line is a good place to start.

2

Work slowly and intently. Doing an outdoor contour is a good opportunity to let your right brain indulge itself while the left brain quiets down.

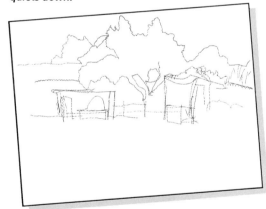

Benefits of contour drawing

Contour drawing helps you see with an artist's eye. First, since you're looking at just one point on the contour at a time, your eyes are ignoring the illusion of three-dimensional depth. In other words, the process of doing a blind contour flattens your subject into lines around the forms.

Second, contour will develop your ability to see, really see, what you're looking at. Rather than the cursory glance the left side of the brain uses to name and categorize things, you must pay attention to all the glorious details the right side of the brain appreciates.

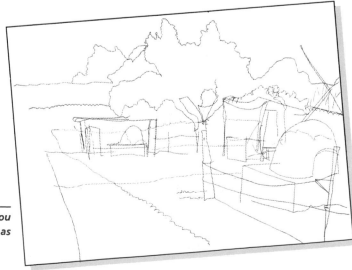

3

Draw as much detail as you can. The object is to see as much as you can, not as fast as you can.

Contour of a Figure

Materials
- *Ebony pencil*
- *One sheet of 18" × 24" newsprint*

Time needed: *Ten to fifteen minutes each. Try at least two or three before going on to the next exercise.*

After you have done a few blind contours of objects and the outdoors, it's time to tackle the figure. Blind contour is the very best way to start drawing the figure. Drawing people is not more or less difficult than drawing a toy or a tree. Take it one line at a time; as always, draw as if your pencil could touch the point upon which your eyes are focused. Remain objective and detached as you draw.

Keep in mind that you're drawing only when you are actually looking at your subject. Don't expect your drawing to look much like the person you are drawing. (After all, you aren't looking at the paper.) The more contour drawing you do, the more accurate your drawing will become, but in the beginning, they might not look like much. On the other hand, you might be pleasantly surprised at how "truthful" they turn out.

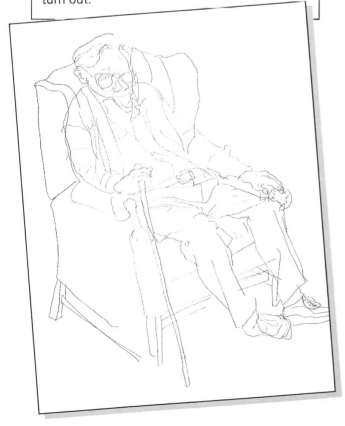

1

Sit close enough so you can see the whole figure, but not much more. Draw the silhouette shape first.

2

Draw the internal contour lines, starting each at the outside edge and drawing in. As you draw, notice shapes only. It doesn't matter whether it's a nose or chin or some part that doesn't have a name.

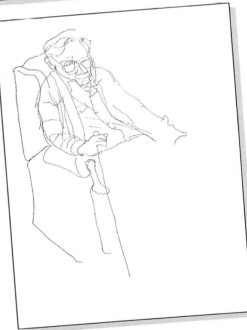

3

Maintain the conviction that the pencil point is touching your model, point by point, as your eyes move along the contours.

Continuous Line

Materials
- *Ebony pencil*
- *One sheet of 18" × 24" newsprint*

Time needed: *Ten to fifteen minutes*

This time set up a still life with several objects that you like to draw, or ask a friend or family member to pose. Do a contour, but this time *do not pick up* the pencil even once as you draw—make the entire drawing with one very long stroke. If you have to draw the pencil across the paper, do it, but don't lift the pencil up. Make it a game with yourself to see if you can find a path that will keep the contours continuous. Think of it as a puzzle or maze. You may redraw over a line twice if you need too.

1

Pick a convenient point on your subject matter, and place your pencil on the paper in a corresponding location. Begin drawing, keeping your eyes on your subject.

2

Don't look down! Keep the pencil moving. You will lose any sense of just where your pencil is on the paper, but you should always feel as if you are still in contact with the point you are focusing on.

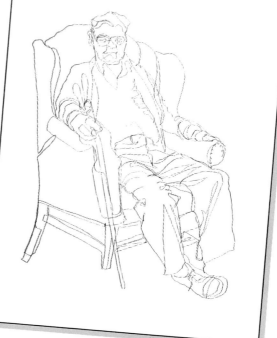

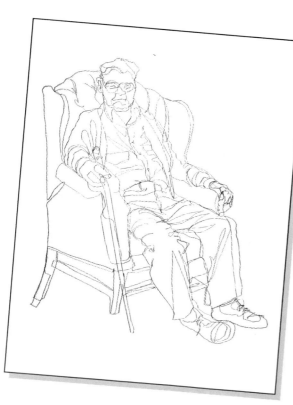

3

You may find it necessary to move the pencil back over contours you have already drawn. Do it. Don't hesitate to redraw any part of your subject.

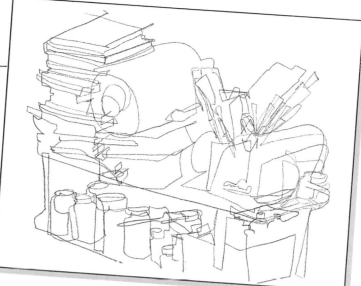

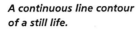
*A continuous line contour
of a still life.*

*A continuous line contour
of an interior.*

*A continuous line contour
of a landscape.*

What not to worry about

When you do look at your blind contour drawing, either after your drawing is completed or when your forget yourself and look down out of habit, you may be surprised or even dismayed at what you see. Your drawing may not look at all like your subject. However, what your drawing looks like is not important. What's on the paper is merely a record of where your eyes have been. If it looks like a tangle of lines, fine. In time, as you coordinate your hand to follow the eye accurately, your drawings will begin to look more and more like what you see.

In fact, most contour drawings won't look like anything most people would think a drawing should look like. Contour drawing is about giving the artist the right kind of experience. Even if your first contour drawing looks terrible, you will still be getting all the benefits—if you are concentrating on co-ordinating eye with hand, the act of vision with the sense of touch.

Contour of a Complicated Object

Materials
- Ebony pencil
- One sheet of 18" × 24" newsprint

Time needed: Ten to thirty minutes each

One important benefit from doing a lot of contour drawing is the development of your patience. It often comes as a very pleasant surprise to people who were convinced they could never draw, that if they took the time to draw what they see, slowly and one small piece at a time, they really could do something that looks good.

This exercise will give practice seeing and drawing, bit by bit. Find yourself a complicated object or a complex machine like an old typewriter, an old-fashioned camera, a woodwind instrument like a clarinet, or some sort of old engine. Make sure it has lots of intricate pieces. Then make a blind contour of it, working slowly and carefully. You may have to look down at your drawing occasionally, to keep track of your progress, but don't watch a moving pencil.

The point of this exercise is to really take your time to study and draw a complicated object to prove to yourself that it isn't really so difficult if you take it one piece at a time. Talent has been defined as the infinite ability to take infinite pains.

1

Begin by drawing a contour of the outside silhouette edge. Go all around the outside of your object, establishing the overall shape of the object. Make your drawing large. Remember, this is a blind contour. Draw without looking at your paper.

2

Now begin drawing the interior contours. Don't skip anything. The point is to really study your object, one tiny piece at a time. You may find it necessary to look at your paper frequently to start the next piece, but only draw while you are actually looking at the object.

3

Take your time. Let yourself become absorbed by the intricate nature of your subject. Try to see the "little glories," the details that you have never bothered to see before.

Cross Contour

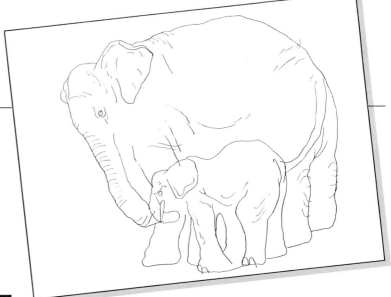

Materials
- *Ebony pencil*
- *One sheet of 18" × 24" newsprint*

Time needed: *Ten to fifteen minutes each*

In the previous exercise, blind contour, you were coordinating the movement of the eye along the contours of your subject with the movement of the pencil on the paper. Any edge, distinct color change, wrinkle, border or linear mark could be traced with the eye. Essentially, what you were doing was searching out the *lines* in your subject matter.

In this exercise, you're not only looking for the visible lines, but you're also going to find what are often called "cross contours." Imagine that a bug with ink on its feet is crawling across the object. As it moves, it leaves a visible trail across the surface of the object. The line does not correspond or follow any edge or border that you would normally draw in a blind contour. If you drew that line the bug was making, you would be drawing a cross contour.

You can trace the track of an imaginary bug across just about any object. You want to feel all the depressions and elevations of the "terrain" the bug is negotiating with your pencil. Feel all the ups and downs, the slopes up, the slopes down and so on. In fact, keeping a vivid image in your mind of our little insect hiker on a trail is a good way to make the experience of drawing cross contours more fun.

1

Draw a contour drawing of the visible contour lines.

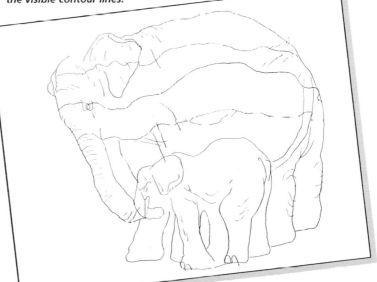

2

Now place your pencil on a point somewhere on the outside contour edge, and begin drawing "cross-country" letting your pencil record all the variations and undulations of the surface.

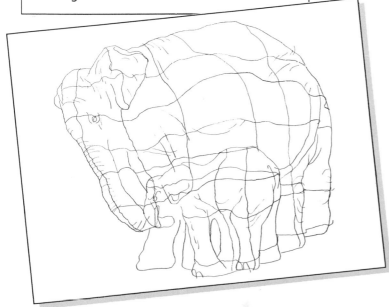

3

Continue drawing cross contours over the surface of your drawing.

Sneak-a-Peek Contour

Materials
- *Ebony pencil*
- *One sheet of 18" × 24" newsprint*

Time needed: *Fifteen to thirty minutes each, depending on the complexity of your subject*

The previous exercises have featured the basic way of doing a contour drawing. Because you are not looking at the paper as you draw, but are drawing "blind" as it were, it is called "blind contour." Because it is also the direct recording of your perceptions as you perceive them, without being filtered through your visual memory, blind contour is also called "pure" contour.

Blind contour is one of the very best exercises for learning to draw. Minute for minute, it offers the most useful training and skill development of all the exercises in this book. However, because of its very nature, there will always be an "accidental" quality to the resulting drawings.

In this exercise, we will bend the rule a bit about not looking at your paper as you draw. In other words, you can cheat a little. I call it "sneak-a-peek contour." Instead of never looking at your drawing as the pencil is moving, in sneak-a-peek contour, you can look down at your drawing periodically to monitor its progress. This will help make a more accurate drawing, because you can make sure lines and angles are of the right length and direction, that closed loops actually close, and that various parts of your subject are in correct proportion to the rest of the drawing.

Comments
The idea of "contour" is also a basic concept in mapmaking. A contour map shows the hills and valleys of the land, just as a contour drawing shows the physical character of your subject.

1

Begin as if you were drawing a blind contour. Keep your eyes on your subject and draw as if your eye and pencil were touching the contours.

2

Glance down at your drawing when you start or stop a line. Check for line length and direction.

3

When you look, see how the line you're currently drawing is related to the other lines. Are the shapes that you are drawing the same shapes that you see? Look for relationships, how one part fits in others and with the drawing as a whole.

4

Keep in mind the spirit of blind contour: make a record of your observations as they happen, drawing only what is before your eyes, exactly as you see it.

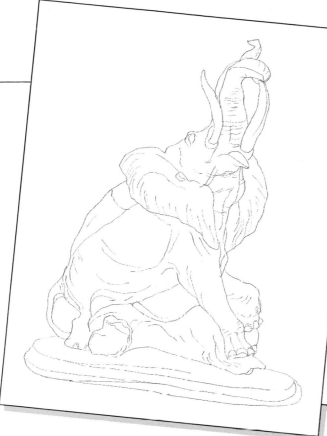

Sneak-a-Peek Contour

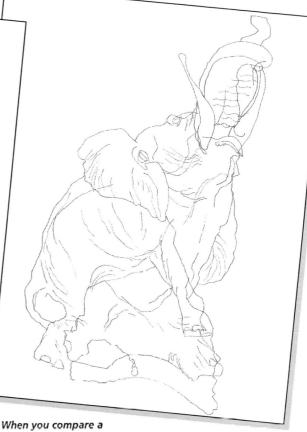

When you compare a sneak-a-peek contour with a blind contour drawing you can see that the former looks more "like a real drawing."

Blind Contour

Do a contour drawing, blind or sneak-a-peek, of your drawing hand, and follow all the rules that I have laid out for contour, but use your opposite hand. That's right, if you are right-handed, draw with your left hand. If you are left-handed, draw with your right. It will feel awkward at first, but let your sense of touch and your eye guide your hand. You will discover that if you relax and surrender control of the hand to the eye, you will make a sensitive drawing. You will discover that drawing is not in the muscles, but in the pathways between your hand, brain and eye. Try other objects with your opposite hand.

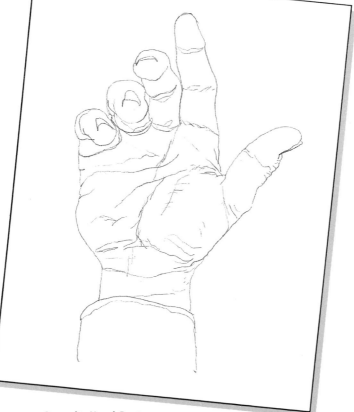

Opposite Hand Contour

Comments

Sneak-a-peek contour is one of the most satisfying ways to draw. It offers more control than blind contour while still focusing on the shapes of things. Sneak-a-peek contour works best if you look only when you really need to. Most of the time you should draw without looking at the paper. Avoid the temptation to become judgmental about your work. Look only to monitor your work, not to criticize it.

Contour of a Foreshortened Object

Materials
- *Ebony pencil*
- *One sheet of 18" × 24" newsprint*

Time needed: *About fifteen minutes each*

This exercise is hard! But it's good for you. Take it as a challenge. Some of the hardest things to draw are objects seen in dramatic foreshortening. Long, cylindrical things seen on end are often very puzzling because you're presented with a view that you're completely unfamiliar with. This drives the left side of the brain into confusion because it can't readily name things when seen this way. This is when you really have to pay attention to the *shapes* of things.

Take an object like a doll, as the example below, or any long and complex object and put it on a stand at your eye level so you see it on end. Do a careful blind contour. You must really concentrate on seeing the true shapes of things. If you do a sneak-a-peek contour, be very wary of drawing what you know about the true length of your subject rather than what actually appears before you.

After you have practiced doing blind contours of foreshortened objects, try doing quick contours (see page 42) of similar subjects, concentrating on seeing the flattened shapes as you draw.

1

Begin by drawing the outside silhouette shape first. Its shape might surprise you because it will be so unfamiliar and unexpected.

2

Continue drawing the interior contours. Be absolutely rigorous in your study of the shapes that you see.

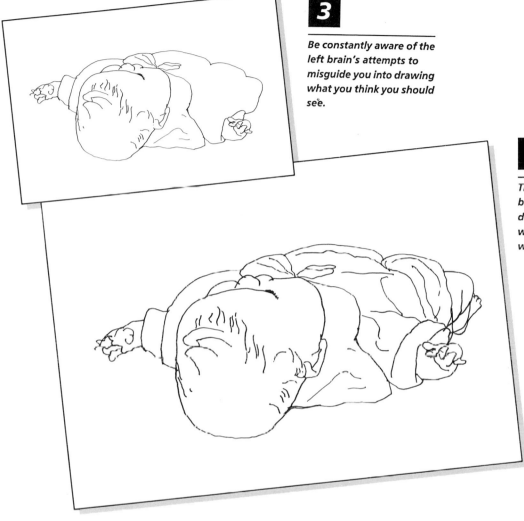

3

Be constantly aware of the left brain's attempts to misguide you into drawing what you think you should see.

4

There is an excellent possibility that your finished drawing will look somewhat odd, but also rather wonderful.

Drawing an object such as this toy tiger from a number of different viewpoints is an interesting challenge. If you can draw dramatically foreshortened objects successfully, you can say you have really learned to draw what you see!

Contour Self-Portrait

Materials
- Ebony pencil
- One sheet of 18" × 24" newsprint

Time needed: Fifteen to twenty minutes

Be your own model! Your first attempt at doing contour drawings of people should be your self-portrait. You will need a mirror set up so you can see yourself comfortably with your drawing board supported in front of you. I sat in a chair and used the back of another to hold the board while I faced a mirror hung on a wall. Sit close to the mirror and if possible arrange the light so your face is not in shadow but no light is shining in your eyes.

Doing a blind contour of your own face is an interesting experience, because you must watch yourself stare back as you draw. It certainly helps overcome the habit of looking down at the paper. It's also an interesting experience to look at yourself for longer than the few minutes we devote to grooming. In a short time, you will lose the original self-consciousness, and you may begin drawing with an unexpected objectivity. You will begin to feel like you're drawing someone other than yourself.

Don't fall into the trap of judging the final drawing critically: "What a lousy drawing!" combined with "Gosh, am I *really* that ugly?" Remember, it's not the product that counts but the process. Contour self-portraits can be the most sincere and searching of drawings if you concentrate on coordinating the movement of the eye with the hand. Let your subconscious do the rest.

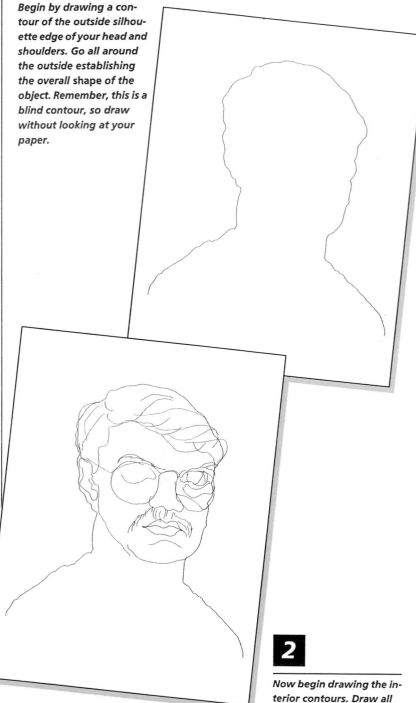

1

Begin by drawing a contour of the outside silhouette edge of your head and shoulders. Go all around the outside establishing the overall shape of the object. Remember, this is a blind contour, so draw without looking at your paper.

2

Now begin drawing the interior contours. Draw all the little details. Don't skip anything and don't abbreviate anything. You may find it necessary to look at your paper frequently to start the lines, but only draw while you're actually looking at the image in the mirror.

3

Finish the drawing, including any eyewear and jewelry. Although you don't have to draw every little wrinkle and whisker, draw enough detail so you can see the texture and direction of the hair and skin.

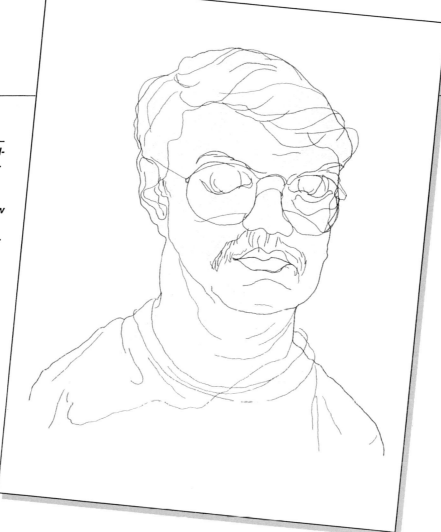

This self-portrait is a continuous line contour.

Comments

I think contour self-portraits produce some of the most interesting drawings, and not just because of the subject matter. Doing one every month for a year can result in a really fascinating series. You can experiment with different head positions, clothing and headgear. You are only limited by your imagination and your field of vision—self-portraits are of necessity almost full frontal views. If you make a series of self-portraits, you can detect subtle changes in mood, expression, in time, in aging. The self-portraits of Leonardo, Rembrandt and van Gogh are worth studying. You will meet a different artist in those pictures after doing your own self-portraits.

Quick Contour

Materials
- Ebony pencil
- One sheet of 18" × 24" newsprint

Time needed: *Five minutes each*

The key to contour is the imagined tactile contact you have with your subject. It is seeing by touching with the eyes. Like drawing on a window as described in Chapter Two, you feel the pencil touching or tracing the edges you see, flattening the forms into shapes on paper.

Earlier, I compared the experience of contour drawing to that of taking a pencil and carefully inscribing a line on the surface of marble statue. Your hand would feel every undulation, every depression or hollow and every in and out, up and down of the surface.

Now imagine you have before you a polished statue of brass, with a smooth, slick surface. Now imagine running your finger along the cold surface of the statue, letting it glide over it. Instead of inscribing a line on it with a pencil, you are gently caressing it with your fingertip. That is the feeling of quick contour.

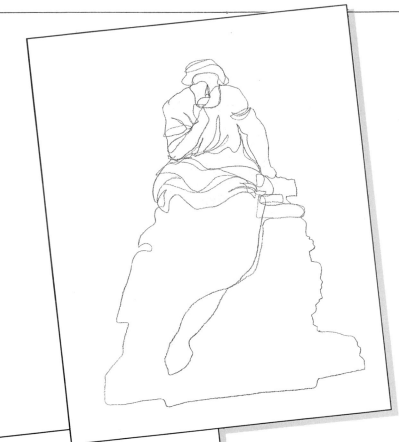

1

Begin by drawing the outside silhouette edge and internal contours of your subject. Let the pencil glide over the paper rather than crawl. Don't look at the paper.

2

Continue drawing the internal contours, maintaining a more rapid movement of the pencil, while keeping your eyes on the subject.

3

Look for the large curves, the sweep and grace of the lines as you draw.

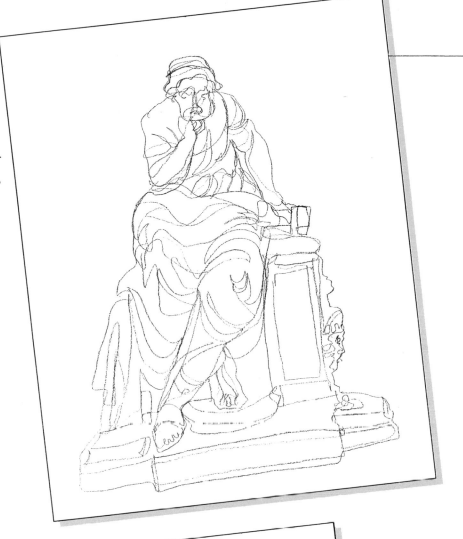

Another example of a quick contour. There is a bit of the feeling of gesture drawing, the subject of the next chapter, in a quick contour.

Comments

Quick contour should still involve the sensation of making tactile contact with your subject, but instead of a slow and detailed search of the contour, it is a dynamic exploration of the larger movements and directions. It is not the penetrating study of blind contour, but a general survey of the sweep, grace, flow and movement of your subject's forms.

Chapter 4 Gesture

The next type of drawing we will explore is the exact opposite of contour drawing, called gesture or scribble drawing. As you will see, gesture drawing is the perfect complement to contour drawing. If contour is about detailed careful observation of surface detail, gesture is about seeing the big picture. Contour is all about seeing one tiny point, the point you imagine your pencil is touching, whereas gesture is about drawing the whole thing at once.

Gesture drawing is often called scribble drawing. It's almost as easy as scribbling, but there are a few simple and important differences that make gesture drawing one of the best ways to improve your drawing.

First, gesture should never lose the loose, almost unrestrained quality of scribbling. In fact, the first gesture exercise is just plain scribbling, the essence of which is loose, circular, spontaneous, and almost wild or thoughtless marking on paper.

So our first guideline is: *Scribble*.

Second, when you do a gesture drawing, you are not only making a loose, scribbly sketch of what the subject looks like, but you are also trying to tell a little more about what your subject is and what it is like. A gesture drawing should communicate information about your understanding of your subject matter.

You are not drawing only what you see, but what you *feel* is the essential character or action of your subject. It is often hard to describe gesture drawing without resorting to almost mystical terms because gesture drawing records your impressions, thoughts and feelings about your subject, and these things are not well suited to verbal (left-brained) expression.

Our next guideline is: *Draw what your subject feels like or what it is doing*.

Gesture is a spontaneous record of what you think best captures the inner vitality of your subject. Draw what your subject is like or what it is doing. If you're drawing a teddy bear, for example, you want to draw the cuteness as well as the shape of the animal. You want your drawing to express the feeling of the teddy bear, its "teddy-bearness."

Sometimes gesture drawings are called action drawings. "Action" names make the most sense when drawing the figure. It's pretty obvious what action the figure is doing, even if the figure

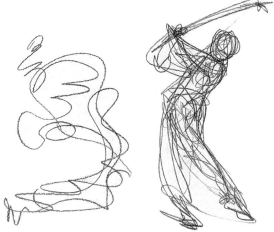

Rule 1: Scribble. *Rule 2: Draw what your subject is doing.* *Rule 3: Don't pick up or stop the pencil.*

is motionless—she or he is standing or sitting, bending, reaching or twisting. But what about things such as a lamp or a telephone? How can you draw what an inanimate object is doing? They can't *do* anything!

One way to think about it is that even a lamp or a telephone is doing something—they are being themselves! So when drawing a telephone, you have to imagine that you are drawing whatever it is a telephone does when it's being a telephone! Silly as that sounds, you would draw a standard telephone differently from a Fisher-Price phone, a pay phone, or an old-fashioned stick phone.

Think of all the objects that are animated in a Disney cartoon. When you see a toaster or coffeepot walk and talk, you can understand how anything can be brought to life with its own unique gesture.

If you are drawing inanimate objects, you not only draw them sitting there, you draw *how* they are sitting there! A teddy bear "sits" differently than a China doll. An old baseball glove "sits" differently than a work glove, a rubber glove, or black lace gloves.

Gesture drawings should only take about a minute or two to complete. You shouldn't work at gesture drawing. Instead, you let them happen. You put the pencil to paper and begin to draw loosely and spontaneously with an uninterrupted movement of the hand and shoulder. Keep your drawing instrument moving, neither stopping it nor lifting it from the paper. Theoretically, one could grab the end of a gesture stroke

and pull the whole thing off the paper as if it were one long piece of yarn on the paper.

The next rule is: *Don't stop the pencil, and don't pick it up off the paper.*

Make your scribble fit the paper so no part of your subject matter is left off. If you start too large, just scribble it smaller right on the paper. Never start over — it's only a minute or so drawing anyway.

Whatever your subject — make it fit the paper. This is one of the most important parts of gesture drawing. If you need to make a mark on the top of the paper for the topmost part of your subject and then make a mark on the bottom for the lowest part, do it. Get in the habit of "sizing" your drawing to fit the paper.

If you consciously try to make whatever you draw fit on the paper, you'll get in the habit of seeing how the size of the various parts of your subject are related. You'll also develop an instinctive sense of proper proportion and composition. You will develop the habit of thinking about how whatever you are drawing fits into whatever size and shape paper you use.

The last guideline is: *Always draw the whole thing on the paper.*

Throw most of your gesture drawings away. Save maybe one in twenty and date it just for a record so you can see how they evolve. They can't really "improve" even though you may like later ones better. Gesture is like breathing — it's not something you do better or worse. If you throw them away, you'll keep your studio space from getting cluttered, and you'll also remind yourself that gesture is an experience not a product. If you work with cheap (better yet, free) materials, you will develop the sense of not making your drawings too precious. You'll get more comfortable and more relaxed when you work.

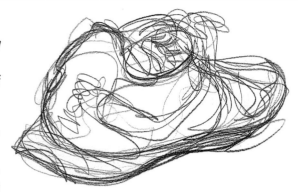

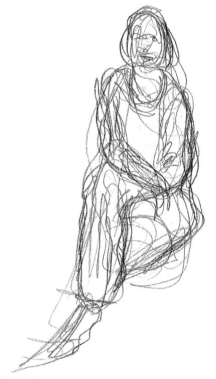

Rule 4: Always draw the whole thing.

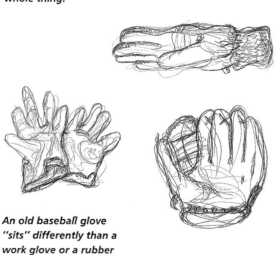

An old baseball glove "sits" differently than a work glove or a rubber glove.

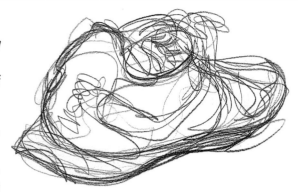

Everything has gesture

Everything has a unique quality that is its "gesture." We can see this best if we compare things and note the subtle but unmistakable qualities that give everything its own special identity. For instance, coffee has a different quality or "gesture" than say root beer or beef bullion. A Geo has a different gesture than a Mercedes or a ten speed bike. Mondays feel different than Fridays; February has a gesture unlike that of April or October. A drawing by Michelangelo will not be mistaken for one by Rembrandt; each artist imbued their drawings with a unique and inimitable gesture.

Let's Look at Gesture

A gesture drawing begins with a line or squiggle on the paper that immediately accounts for the whole thing. Your first gesture mark should tell you right from the start that you're considering the whole entity, not its parts one by one. Even if you simply make a line on your paper that tells you that the uppermost part of your subject is near the top, and the bottommost part near the bottom, you are still thinking about the *whole* gesture.

Draw the entire object on the paper. Don't let it go off the paper's edge. It should fit entirely on the rectangular sheet you are working on.

Continue drawing, loosely, scribbly on the paper. Your next lines should begin developing the big curves or directional forces that express *your understanding of what your subject* feels *like.* Try to see through surface detail to the underlying connections that make it a single unit. Draw what it is, what it is doing, how it makes you feel.

Keep your pencil swirling and gliding over the paper. Don't stop it or pick it up. You might scribble harder, faster or darker those parts of the drawing that seem more intense, more interesting or more important. Other areas might be drawn with lighter, slower lines. A fist might be drawn with hard, dark jagged lines, hair with softer, more flowing lines.

Work in a fluid, unlabored and spontaneous manner. Let the drawing happen. Let the right side of the brain take over.

As the drawing develops, incorporate smaller elements and details, but always with the larger gesture in mind. Keep returning to the initial impulse that you first drew. Never lose sight of the pervasive gesture that unites every part of your subject matter into an indivisible unit.

One of the nice things about gesture is that it's so fast and disposable, you have very little at stake—they're just scribbles. As important to your overall drawing development as gesture is, no one drawing is all that vital. You have opportunity to "goof off" a little, to take chances or just let go.

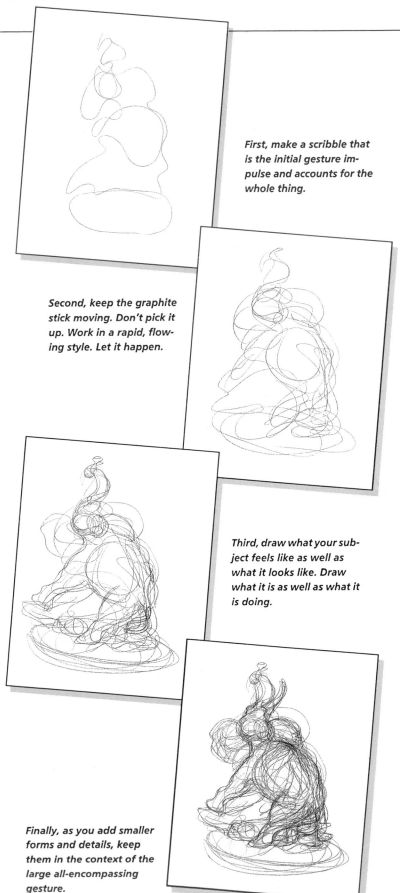

First, make a scribble that is the initial gesture impulse and accounts for the whole thing.

Second, keep the graphite stick moving. Don't pick it up. Work in a rapid, flowing style. Let it happen.

Third, draw what your subject feels like as well as what it looks like. Draw what it is as well as what it is doing.

Finally, as you add smaller forms and details, keep them in the context of the large all-encompassing gesture.

Remedial Scribbling

As surprising as it may seem, you might find scribbling harder than you imagined. Often, we associate scribbling with negative habits—it's out of control, childish, messy, "naughty," sloppy or wasteful.

Before you do one of the following gesture exercises, take a large sheet of paper and the soft graphite stick. Now cover the paper with scribbling. Make big swirls all over the paper. Draw from your shoulder, not from your wrists. Don't stop the hand and don't lift the graphite from the paper. Go back and make some tight curls; then make some jagged zigzags, loops, coils and points.

Notice how it feels. Do you feel any resistance in your muscles? Do you feel that there is something slightly wrong with scribbling? Any leftover feelings from being a kid that this kind of drawing is "bad"? Do you feel the need to have permission to let go? Or is it liberating and fun?

However it feels, do it! Ignore any residual bad feelings about scribbling or any resistance from the left side of the brain. Give yourself permission to let go. Scribble until the page is dark with marks.

I recommend that your first gesture drawings be done with a soft (6B) graphite stick. Koh-i-noor-Hardtmuth and General Pencil are readily available brands. Work on paper larger than letter size (8½ × 11) that is clipped to your large drawing board. A large 18 × 24-inch newsprint pad is well suited for gesture. Almost any kind of scrap paper will do if you can find it. I've found discarded 11 × 15-inch computer printout paper ideal for gesture drawing. If the print-out is still in continuous scroll form, I separate every other perforation so I have 22 × 15-inch pieces. Many schools and businesses dispose of quantities of computer paper and may make it available for artistic recycling.

Take a large sheet of paper and the soft graphite stick and cover the paper with scribbling. Make big swirls, tight curls, loops and zigzags until the paper is covered.

Gesture of Objects

Materials
- *Soft graphite stick*
- *Newsprint or large, scrap-paper-like, used computer paper. (Whenever possible use paper larger than ordinary typing paper.)*

Time needed: *One to two minutes each. Do at least ten.*

We will begin by doing gesture drawings of objects that can be found around the house. It's easy to gather an assortment of things for gesture such as tools, kitchen items, toys, knick-knacks, decorations and so on.

Here is a series of gesture drawings of small objects such as tools, toys, statues and shoes. Look around for small objects that you can set on a tabletop in front of you. I looked for interesting things around the house, but found that the prospect of making gesture drawings made almost anything interesting.

1

Draw a few lines that account for the entire object. Make it fit the paper.

2

Keep the graphite stick moving, recording your sense of the object's essence.

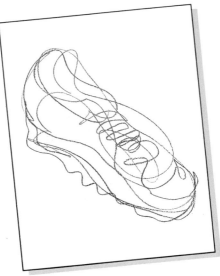

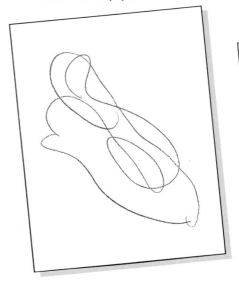

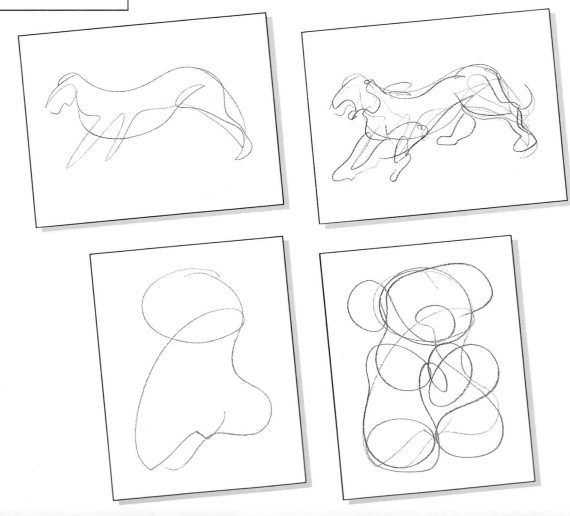

3

Don't pick up the graphite as you draw; keep it in contact with the paper. Don't draw parts; draw the whole gesture.

4

Leave details for last. Stop when you feel you have captured the inner nature of your subject.

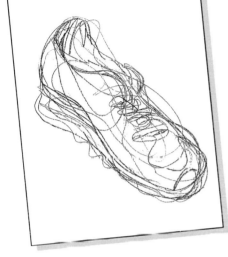

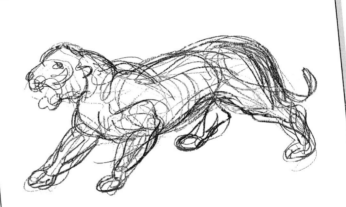

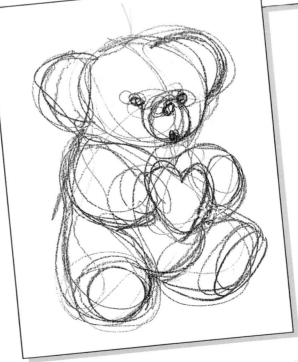

Comments

Your first gesture drawings might not look like anything at all, at least not like anything you might want them to look like. The first ones may end up looking like a tangle of wire, and the experience might not be all that satisfying.

The left side of your brain might be very uncomfortable with the whole notion of gesture. It will make you think that it is a waste of paper, or at least a waste of time.

In the beginning, what your gestures look like is unimportant. Simply do them as best you can, and do as many as you can. The process, like that of contour, is more important than the product. Experience is the goal, not good drawings. With enough of the right experience will come interesting, expressive and satisfying gesture drawing.

Gesture of a Complicated Object

Materials
- One stick of soft (6B or 4B) graphite
- Newsprint or large, scrap-paper-like, used computer paper. (Whenever possible use paper larger than ordinary typing paper.)

Time needed: About two or three minutes each

Find some complicated objects or machines, such as old typewriters or cameras, musical instruments, model ships, engines of all sorts, lawn mowers, or kitchen appliances like food processors. You might look in the garage, attic or basement.

Complicated objects with lots of intricate parts or complex workings make excellent subjects for contour and are great for gesture studies as well. Instead of hunkering down to draw *all* the bits and pieces as you would in contour drawing, you must do the opposite when drawing gesture.

Look for the *big* picture—the uncomplicated unity of the object. Its big shape or configuration should be drawn first. Seeing the underlying simplicity of things is a right-brain function. The left side scans the surface for identifying details from which to generalize; the right side can see *through* the details to the larger pattern beneath them. Seeing that underlying, unified pattern will be very important when you begin to "think compositionally" in Chapter Seven.

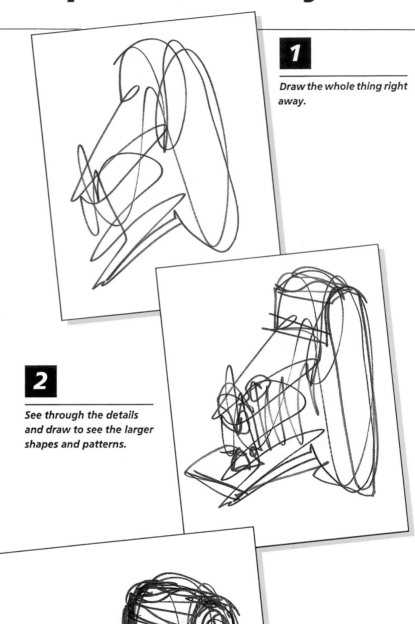

1 Draw the whole thing right away.

2 See through the details and draw to see the larger shapes and patterns.

3 Add details last.

Gesture of Statues or Figurines

Materials
- *One stick of soft (6B or 4B) graphite*
- *Newsprint or large, scrap-paper-like, used computer paper. (Whenever possible use paper larger than ordinary typing paper.)*

Time needed: *About two or three minutes each*

Before trying gesture drawings of people, try doing gesture drawings of statues or figurines. I heartily recommend you acquire an assortment of small plaster or ceramic statues of the human figure. There are some very fine plaster statues of the male and female figure, both draped and undraped, available from mail-order firms such as Montoya Sculpture Supplies. They are also often available from local ceramics and plaster-craft shops. Try your Yellow Pages.

Ceramic supply and craft stores also carry many other statues that make great things to draw. You can find some dandy ceramic animals that make excellent objects for study, not only for gesture but for many other exercises in this book. Buy them already fired, or ask for them to be fired for you; greenware (unfired ceramic ware) is too fragile.

Look for interesting statues to draw in antique shops, flea markets, secondhand or thrift stores. Now you have a good reason to buy that tacky Elvis statue you saw at the local Goodwill shop!

Toys such as dolls and large rubber soldiers will also provide great practice and will help prepare you for drawing real people.

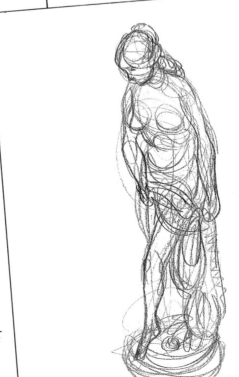

1

Always draw the entire statue or figure from the beginning. Make it fit the paper. Get into the habit of developing good habits; don't chop off parts of your drawing with the edges of the paper.

2

Work loosely, keeping the graphite gliding over the paper. Respond as naturally and automatically as possible, recording your understanding of the energy "trapped" in the statue.

3

Even in the final stages of a gesture drawing you should be letting your hand roam all over the drawing, "refreshing" the energy. Gesture begins and ends whole.

Gesture of People

Materials
- Soft graphite stick
- Newsprint or large, scrap-paper-like, used computer paper. (Whenever possible use paper larger than ordinary typing paper.)

Time needed: One to two minutes each

By its very nature, gesture is ideally suited for drawing people. Once you have had a little practice drawing inanimate objects, you will want to draw living, moving subjects. Your family and friends can be your first models, even if they are unaware of it!

The best way to learn how to do gesture scribble drawings of people is to work with a cooperative model. This person can be a family member or friend. It could be an artist friend with whom you can trade posing sessions or a clothed or nude model engaged for a modelling session with fellow artists.

It helps if you give your model, whomever it is, good instructions. Begin by asking them to assume poses based on everyday activities such as sitting attentively on a chair, slouching on a chair, sitting on a chair facing over the chair-back, standing in a subway or bus, leaning against a wall and so on. Each pose shouldn't last more than a minute to a minute and a half, never longer than two minutes.

Then request they "play statue" in a pose based on ordinary activities such as swinging a bat, tennis racket or golf club, sweeping or raking, and chopping wood.

Once your model begins to literally "get into the swing of things" ask for more imaginative poses, all based on some specific action or activity. (This can be a lot of fun, by the way, and if you are alternating being artist and model for friends, posing will give you a lot of insight into what gesture is all about.)

1

Draw a few lines that account for the entire pose right away. You should know after five seconds of drawing if it will fit the paper. In the first seconds of the drawing you can expand or contract your scribbles to accommodate the paper.

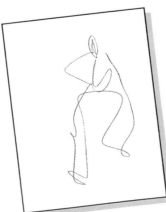

2

Keep the graphite stick moving, recording the action. You are picturing what the model is doing. Gesture is an image of action, or implied action.

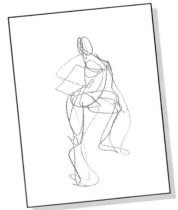

 3

Don't stop or pick up the graphite; to do so would disrupt the unity of the drawing. Don't draw parts; draw the whole gesture.

 4

Don't worry about what your drawing looks like. The goal is to practice identifying the gesture, distilling or extracting it so it can be presented on your paper.

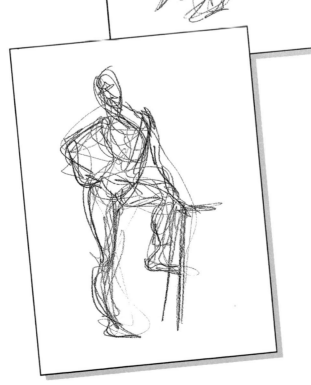

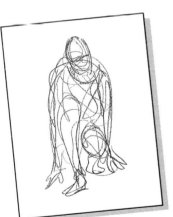

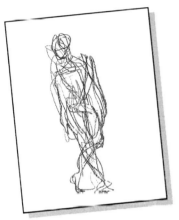

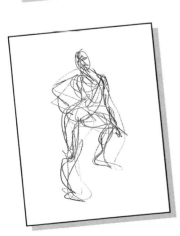

Comments

Drawing gestures of people can be one of the most exciting and rewarding ways of drawing. The more you do, the more insight into the nature of "gesture" you gain. Since gesture drawings take only a minute or so to do, it's not too difficult to do hundreds before you know it. And you will need to do hundreds of gestures! Before that thought frightens you, if you did just five gesture studies each day—five minutes a day—you would have done one thousand drawings in about six months.

Figure Drawing Tips

Here are some suggestions that might make your gesture drawings of people more penetrating and expressive. Don't try to remember all of these ideas all the time. Read these suggestions over occasionally and let them settle in your unconscious mind. They will surface, unbidden, when you are ready to incorporate them into your drawings.

Look for the big curves. Look for and draw the large curves of the human figure. The body contains some beautiful, uniquely human curves. Don't straighten them out! In particular, look for the sinuous "S" curves of the spine. The lithe curve of the spine often determines the action quality of pose. Many times this curve is echoed or repeated in other curves of the figure, especially in the long bones and muscles of the arms and legs. Don't stick a pole up your drawing's back!

Exaggerate the action. It's better to accentuate or even exaggerate the feeling of action in your gesture drawings rather than to reduce it. Overdo, don't underdo feeling. Most of us have a natural tendency to understate the sense of life and movement in our gesture drawings, so we must consciously emphasize it whenever we can.

Include props that are part of the action. If your model is using something that is an integral part of the action of the pose, draw it. If he or she is sitting, draw the chair. Don't draw the model hovering in midair. If he or she is swinging a tennis racket, draw the racket.

Draw groups as a single unit. People are gregarious. They like groups. When you have occasion to draw people in groups, first draw the group as a whole, then draw individuals. Always look for the biggest unit.

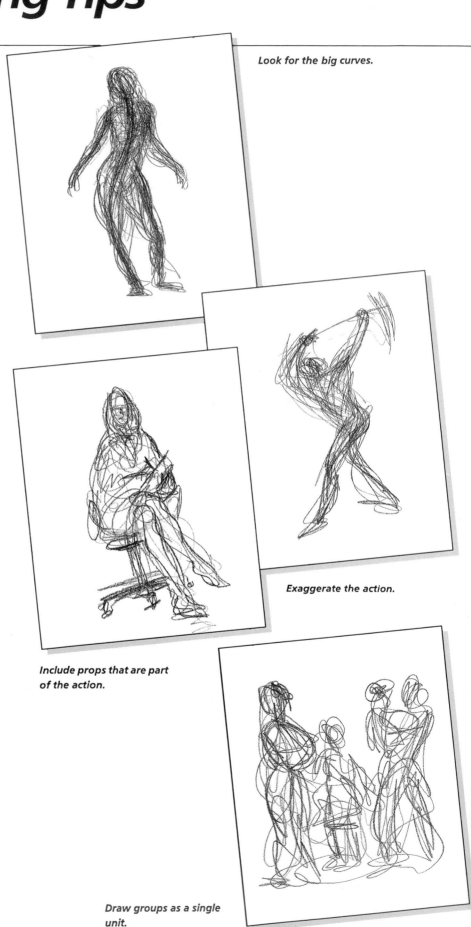

Look for the big curves.

Exaggerate the action.

Include props that are part of the action.

Draw groups as a single unit.

Things to Avoid

Although gesture drawing should be as free and spontaneous as possible and not dictated by lots of rules, there are some things to watch out for.

What we call gesture resides inside our subjects. It's not visible on the outside. Gesture is *felt* rather than seen. All too often we can lose our sense of the indwelling gesture and draw surfaces and especially edges.

Don't just draw the edges, as in the "gingerbread man" example. Look for lines of force that correspond to the deeper dynamics of gesture.

Don't make the same kind of marks or use the same hand motion for every gesture. If you draw with a shaky back and forth motion, or with tiny circular motions, "abominable snowmen" or "nervous Nells" result.

Don't draw the figure bigger than your paper so you crop off hands and feet with its edge. No amputees! Always make the whole figure fit the paper.

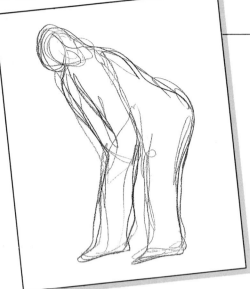

The Gingerbread Man

Comments

When drawing the figure, remember that gesture wells up from the core. It's the "spirit" of your subject that is its gesture. Gesture is in the muscles and bones, not on the skin or clothing.

The intuitive recognition of gesture in scribbled action drawings separates them from contour, which is all about seeing carefully and singlemindedly. Both gesture and contour are about feeling; you "feel" gesture with your heart; you "feel" contour with your eyes.

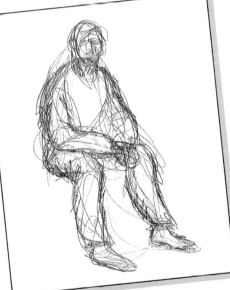

The Abominable Snowman

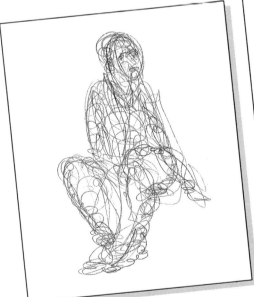

The Nervous Nell

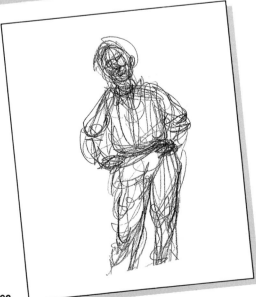

The Amputee

Gesture of Pets

Materials
- *Soft graphite stick*
- *Newsprint or large, scrap-paper-like, used computer paper. (Whenever possible use paper larger than ordinary typing paper.)*

Time needed: *One to two minutes each*

Family pets such as cats and dogs are good subjects for rapid gesture. You do have to work fast, unless they're sleeping. It is essential that you look for the most expressive lines of action. Carry a sketchbook and follow your cat or dog around the house, making five or ten second scribbles when the opportunity arises.

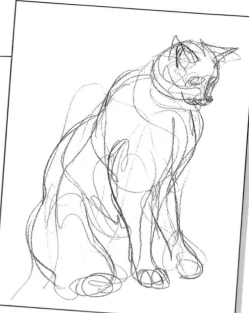

Draw a few lines that describe the big shape of the animal.

Work quickly. If the animal begins to move, study how it moves while you keep the graphite stick moving. Keep drawing!

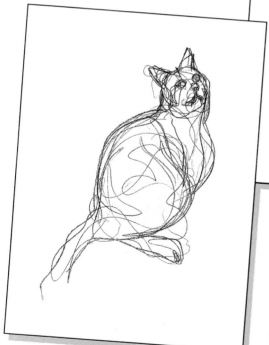

With each drawing, you gain a little more knowledge about your pet's personality. Your gestures will contain more of its spirit.

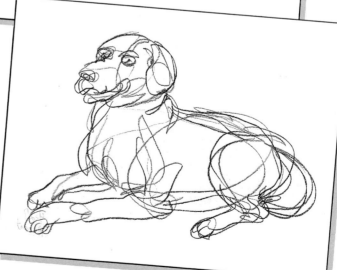

Pay particular attention to the long curves in the body—the uniquely feline arch of a cat's spine, or the inimitable droop of a slumbering dog.

Letter Shapes

Materials
- *One stick of soft (6B or 4B) graphite*
- *Newsprint or large, scrap-paper-like, used computer paper. (Whenever possible use paper larger than ordinary typing paper.)*

Time needed: *Thirty seconds*

One very useful way to see the gestural energy laden in a pose before you is to look for and draw the pose as a simple letterform. Maybe the figure has one hand on her hip with feet together and reminds you of the letter "P." If she moves her feet apart, maybe it's the letter "R." Arms out, feet together, and it's the letter "T" and so on. Draw that letter as the initial gestural impulse.

Look to see if the pose of your model reminds you of a simple letterform. Draw that letter shape first.

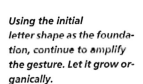

Using the initial letter shape as the foundation, continue to amplify the gesture. Let it grow organically.

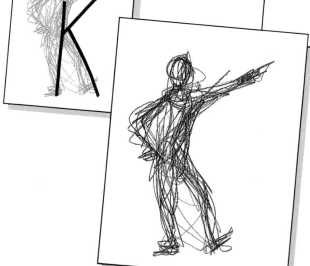

Although the initial letter shape might be lost in the subsequent embellishments, it should still guide the hand as the drawing is detailed.

Comments
The first few seconds of a gesture drawing are very important. In those few moments, the complete and entire gesture should appear on the paper in its barest, but still complete nature. Gesture in a sense is born whole. An impartial gesture drawing is a contradiction in terms.

Use Ink and Cotton Swabs

Materials

- Bottle of black India drawing ink or black writing fluid
- Cotton swabs
- Optional small cup to hold about a tablespoon of ink
- One sheet of 18" × 24" newsprint or large, scrap-paper-like, used computer paper. Also works well on the sheets of the daily newspaper that have no pictures, like the classified ads or the financial page.

Time needed: Thirty to sixty seconds for each drawing

Gesture drawing can be done with a lot of different materials. Drawing tools that make decisive marks rapidly are the best. In this project you're going to use cotton swabs dipped in black ink, a drawing tool that might sound unlikely at first. However, you will discover that an ink-filled cotton swab will make very bold dark marks.

These drawings will probably be quicker to do than with the graphite stick, because they get dark and more tangled faster.

One way to draw with the ink-saturated swab is to see if you can make a complete gesture with just one dip in the ink.

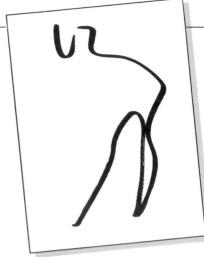

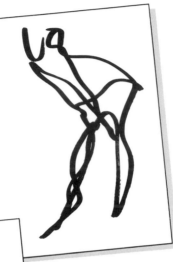

1

Draw the largest and most descriptive curves first.

2

Crystallize the energy with as few strokes as possible.

3

Finish with only the most telling details. Drawing with the ink and cotton swab is an exercise in economy.

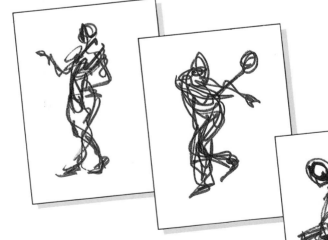

Comments

Cotton swab gesture drawings often have a powerful calligraphic quality. In fact, there is something in them reminiscent of Oriental brush painting.

Variations include using pipe cleaners, cosmetic brushes, toothbrushes dipped in ink, as well as homemade pens fashioned from bamboo, twigs, sticks, and feathers. In fact, almost anything you can dip into ink will render an interesting drawing.

Use the Side of the Charcoal

Materials

■ *One stick of black Charkole, broken in two, or a one-inch piece of large black or purple crayon with the paper wrapper peeled off. The large fat crayons made for schoolchildren are ideal; they are easy to hold and make nice wide strokes.*

■ *Newsprint or large, scrap-paper-like, used computer paper.*

Time needed: *Thirty to sixty seconds each*

Gesture drawing is the product of three factors: the energy contained in the subject matter, the artist's personality, and the nature of the materials the artist is using. As you might have discovered with the ink and cotton swab gestures in the previous exercise, the materials you use *are part of the gesture.*

In this exercise, don't draw with the point of the graphite stick, but with the *side* of a one-inch-long piece of a black crayon or Charkole. (The charcoal will make some dust, so be careful of the mess.)

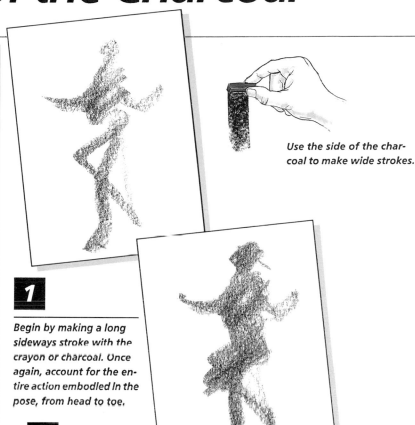

Use the side of the char-coal to make wide strokes.

1

Begin by making a long sideways stroke with the crayon or charcoal. Once again, account for the entire action embodied In the pose, from head to toe.

2

Continue to elaborate on the initial gestural impulse, using the side of the crayon. Since you can't use the point, you can't outline the shapes.

3

The wide strokes of your crayon will begin to fill up the volumetric shapes that are suggested. Stop before your drawing gets too solidly dark.

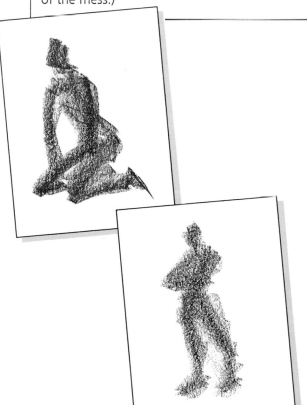

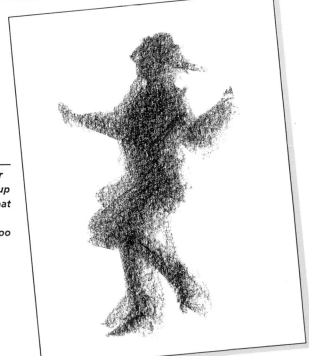

Gesture of Television Images

Materials
- *Ebony pencil, pen or marker*
- *Small pad of paper*

Time needed: *Each drawing will take less than thirty seconds. Do as many as you can in five or ten minutes or as long as you can sustain the necessary attention.*

Even your time watching television can be an opportunity to practice drawing. In fact, drawing from the TV is one sure way of making that time worthwhile.

Sit so you can see the television screen and your drawing pad without strain. Don't sit too close or in inadequate lighting. Work on a smaller scale than you would for other gesture drawings. Working on a pad of paper smaller than typing paper is a good idea.

Don't start with a preconceived notion of what your TV gestures should look like. Start with one figure and draw his or her movement. Draw continuously even as the scenes change. Work as loosely as possible. Let the action on the screen suggest things. Keep your mind open and receptive to ideas.

Try ruling your paper into a grid of small rectangles approximately three by four inches in size. Make your drawings in these "screen" size frames, moving from one to the next as the flow of action on the real screen suggests.

TV gestures will be by necessity "flash" gestures or partial memory drawings. Most will not look like anything in particular, but they're still fun and good training. If you have a VCR, you can draw while watching a favorite video. Some newer video equipment can even slow down the action or freeze-frame an image in action for closer study. What a neat way to learn to draw people in action!

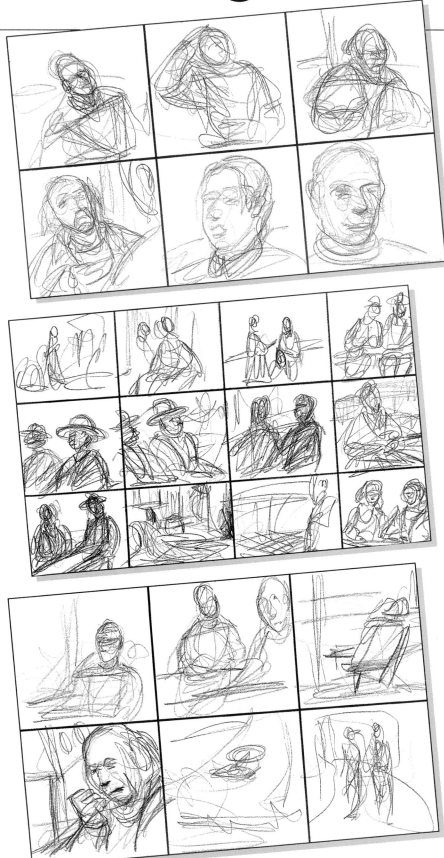

Your television can be a great source for making quick "flash" gestures.

Draw Yourself in the Mirror

Materials
■ *One stick of soft (6B or 4B) graphite, Ebony pencil, or whatever instrument you feel comfortable with*
■ *Newsprint, used computer paper, small sketchpad*
Time needed: *About one or two minutes each*

You need a full-length mirror, a pencil, and a portable sketchpad to make gesture drawings of yourself. Draw the image you see in the mirror as you take different poses. You'll be surprised at the number of poses you can assume and still see yourself to draw. Try standing, sitting on a chair or on the floor, resting one foot on a stool or box, in different coats or hats.

Draw yourself drawing yourself.

Use your imagination for new poses.

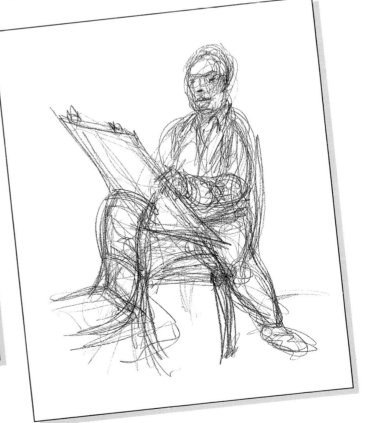

Try this periodically to see how your own view of yourself changes.

Gesture Variations

To keep from getting into unchallenged habits, vary your procedure from time to time in small but significant ways. For instance, every once in a while switch hands and draw with the opposite hand. It will feel awkward at first, as it did when you drew your first contour drawing with the "wrong" hand. However, remember the important points about gesture: draw the action, draw the whole thing, don't stop or pick up the instrument, and keep the big picture in mind.

Try starting at the bottom of the paper and working up. This procedure is contrary to your normal habits of vision. You'll naturally be more mindful of fitting the whole image onto the paper. It's much more disturbing when you leave off the head of a figure than the feet.

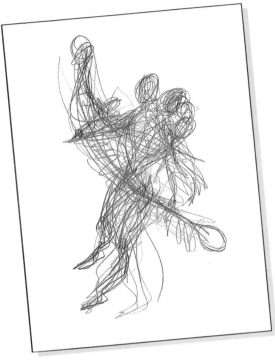

Moving Gesture

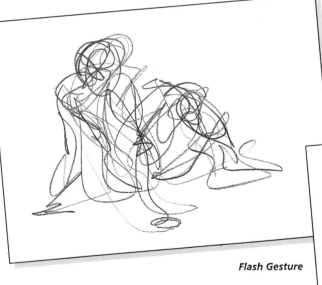

Flash Gesture

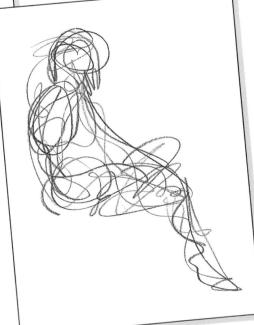

Ask your model to perform some repetitive action for about three minutes. For example, instruct the model to pretend he or she is picking up a box and placing it on a high shelf, or that he or she is chopping wood, swinging a golf club or a baseball bat. The model repeats the same action for the duration of the drawing.

Do a gesture drawing of the movement. Your subject matter is the action itself, not the body performing it. Make whatever marks you need on your paper to express the activity as it occurs in space and time.

There are no right and wrong ways to do this drawing. Five artists drawing the same action would invent five different ways to show motion.

Ask your model to do a series of poses, one right after the other, changing every thirty seconds. Arrange your paper on your board so you can pull one sheet off and work on the next quickly. You only have enough time to establish the initial impression of the gesture, though it will still be a complete one. Ignore details. Go for the grand view, the big picture.

After doing ten flash poses of thirty seconds each, ask your model to change every twenty-five seconds and do ten more. Then reduce the time to twenty seconds, then fifteen, and finally ten.

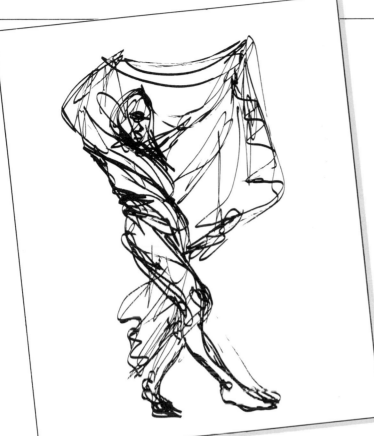

*Gesture of Figure With
Drapery*

Ask your model to experiment with poses using a bed sheet. Ask him or her to wrap or drape the sheet around themselves, or to hold it in various ways. Do a gesture of the way the fabric reacts to the body beneath it or to the pull of gravity. The way the folds fall and flow is the gesture of gravity made visible. This exercise is great training for drawing the folds of clothing.

Memory Drawing

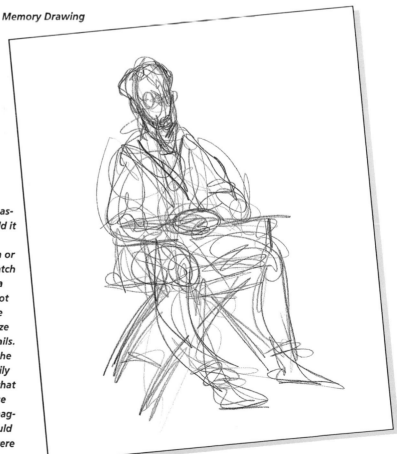

Instruct your model to assume a pose and to hold it for a full minute. The model can position him or herself so a clock or watch is visible (or counts to a hundred silently). Do not draw. Instead study the pose carefully. Memorize the action, not the details. You can't retain what the model looks like as easily as you can remember what it is doing. Feel the pose with your own body. Imagine what that pose would feel like if your body were holding it.

Extended Gesture

Materials

- *18" × 24" newsprint*
- *Ebony pencil*

Time needed: *Five minutes for each gesture drawing*

A gesture drawing is by its nature a momentary thing. Because gesture is in a way "alive" (even if the subject matter is inanimate, *you're* not!), it is always changing—dynamic and vibrant.

In this exercise, instead of doing a gesture in a minute or so, spend five minutes (a very long time for a gesture) on one drawing. Include *all* the details, all the nuances, even any changes that might occur in that time. If you're working from a live model, the pose can very gradually shift as the model's muscles become fatigued or relaxed.

Even though you are including as much detail as possible, keep going back to the original all-encompassing impulse, the gestural energy that binds all the pieces into an indivisible whole.

Use an Ebony pencil, fine marker, ballpoint pen or whatever drawing instrument won't let the drawing get dark too fast.

1

The five minute extended gesture begins like all gestures: the first marks on the paper should begin accounting for the whole figure. A gesture that might last five minutes begins the same way a thirty second gesture does.

2

Continue to modify and enhance the original drawing. Seek out those lines and marks that express your own understanding of your subject.

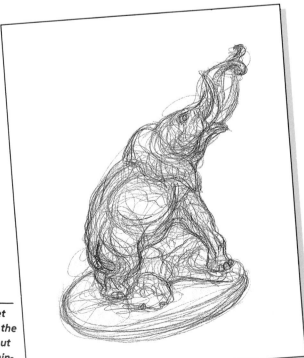

4

Your drawing might get rather dark as you near the end of the time limit, but draw for the full five minutes.

3

As you scribble, incorporate as much detail as you can, but don't lose touch with the unifying gestural energy.

Gesture and Contour Compared

If we think of contour and gesture as polar opposites, as two pure extremes, we must then begin to bring the two together. We want to retain the acuity of vision and sensitivity of blind contour and blend it with the free and expressive nature of gesture. The really great draftsmen do both.

Here is a series of three drawings of the same object to show the difference between quick contour, blind contour and gesture. The gesture drawing took two minutes; the quick contour took five minutes, and the blind contour took twenty minutes. The drawings differ considerably in amount of detail and "spirit." There is a place for each in your repertoire.

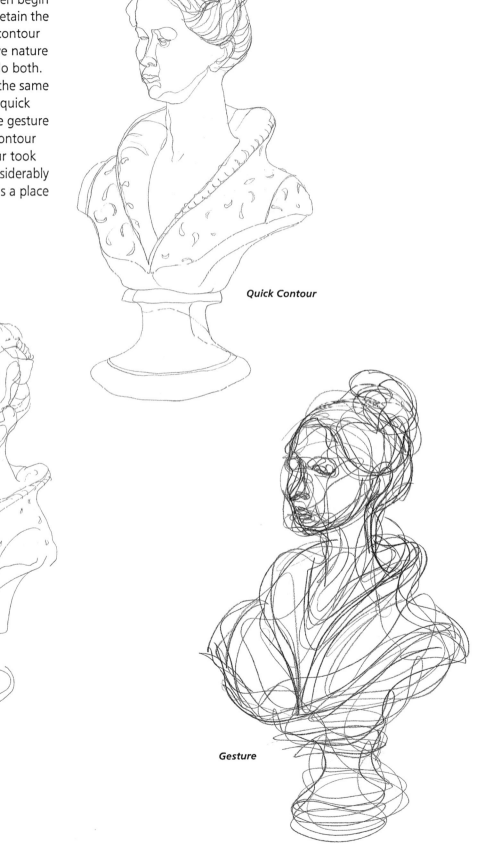

Quick Contour

Blind Contour

Gesture

Chapter 5 Volume and Weight

Gesture and contour each capture a distinct character of your subject matter. Contour focuses on the edges and lines of the subject; gesture on its invisible forces of energy. Contour renders the subject into a set of rather spidery lines on the paper, while gesture renders it into an almost chaotic tangle of scribbles. Neither captures the sense of physical weight exhibited by your subject; gesture and contour are not particularly good at expressing the solidity or weight of what you are drawing. Yet it is volume and weight that will make your drawing convincingly lifelike.

Although I have been talking about the process of seeing three-dimensional *form*, and drawing two-dimensional *shape*, we still want to give our drawing the impression of substance. Besides the visible appearance of an object, it is the *weight* and *volume* that make something tangible for us. So too in our drawings. To make them believable, we need to communicate the way things take up space and feel heavy or light. Our drawing must suggest substance in space by incorporating clues to the mass and placement of what we draw.

The artist most keenly conscious of the volume and weight of his or her subject is the sculptor. It is part of the sculptor's job to understand the way three-dimensional things take up space and have weight, and to re-create it in a different medium.

Now let's look at ways to think about and understand the volumetric component of an object. The first one is called a "wire frame" drawing, borrowing a term from computer-aided design or engineering.

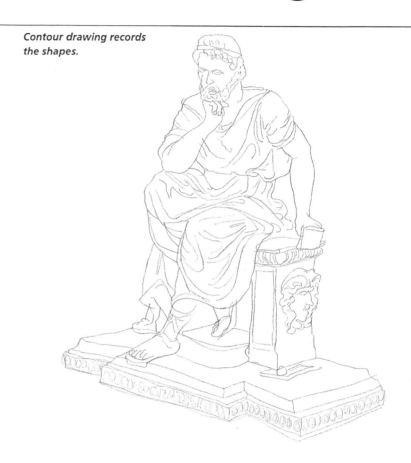

Contour drawing records the shapes.

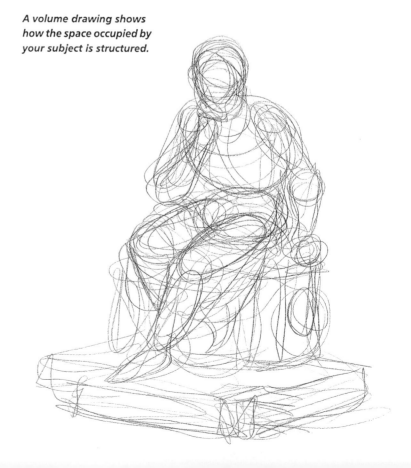

A volume drawing shows how the space occupied by your subject is structured.

*Gesture drawing captures
the action and energy.*

*"Wire frame" drawing
analyzes the geometric
components.*

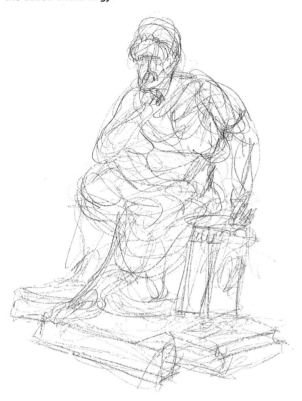

*The "mummy" drawing
expresses the roundness
of form.*

*Mass drawing displays the
bulk and weight.*

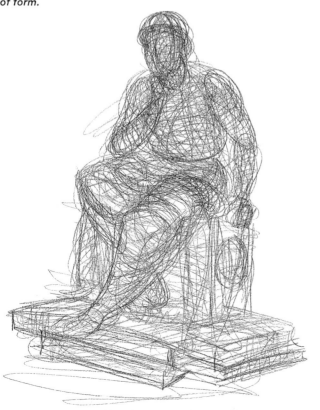

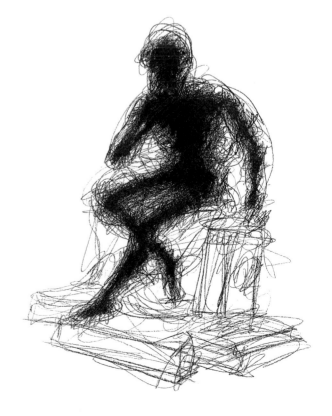

"Wire Frame" Drawing

Materials

■ *Cheap paper such as blank scrap paper or used computer printout paper*
■ *Ebony pencil, with a sharpened point*
Time needed: *Two to five minutes per drawing*

This exercise is borrowed from a concept used in engineering and computer-aided design. Designers use wire frame drawings generated by computers to show with a few key lines the forms and shapes of complex objects. Solid form is rendered as if the object had been bound by wire and then removed, leaving the wires intact, hence the name. A wire frame drawing has an almost skeletal quality, but the dimensions of the object and the volumes it enclosed are quite clear.

In this exercise you will create a more informal drawing than a computer would make, but the idea is the same. Draw your subject as if it were bound by wires or cords and you are drawing only the wires, even the ones that were hidden by the object. Pretend your subject is made of transparent material enabling you to see the wires all around the forms, or that you could remove the object without disturbing the wires.

This exercise is a variation on contour drawing. Many of the lines will correspond to cross contours.

Even though we are borrowing an idea from engineering, you don't have to make your drawing that exact. Simply draw the "wraparound" lines with the aim to describe your object's component forms.

Establish the silhouette shape of the entire object.

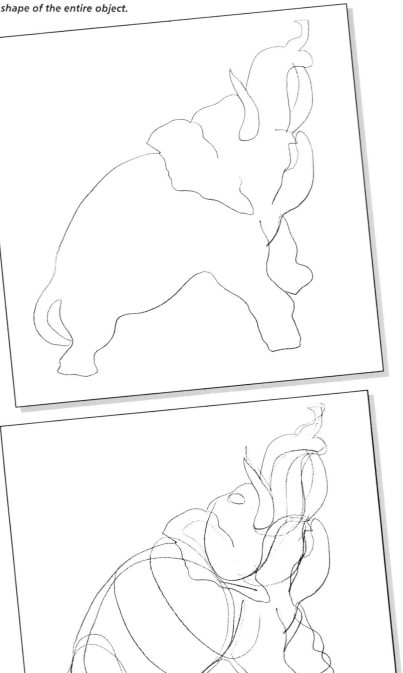

2

Delineate the larger masses, seeking out the key contours. Look for the "pieces" or building blocks that make up the object.

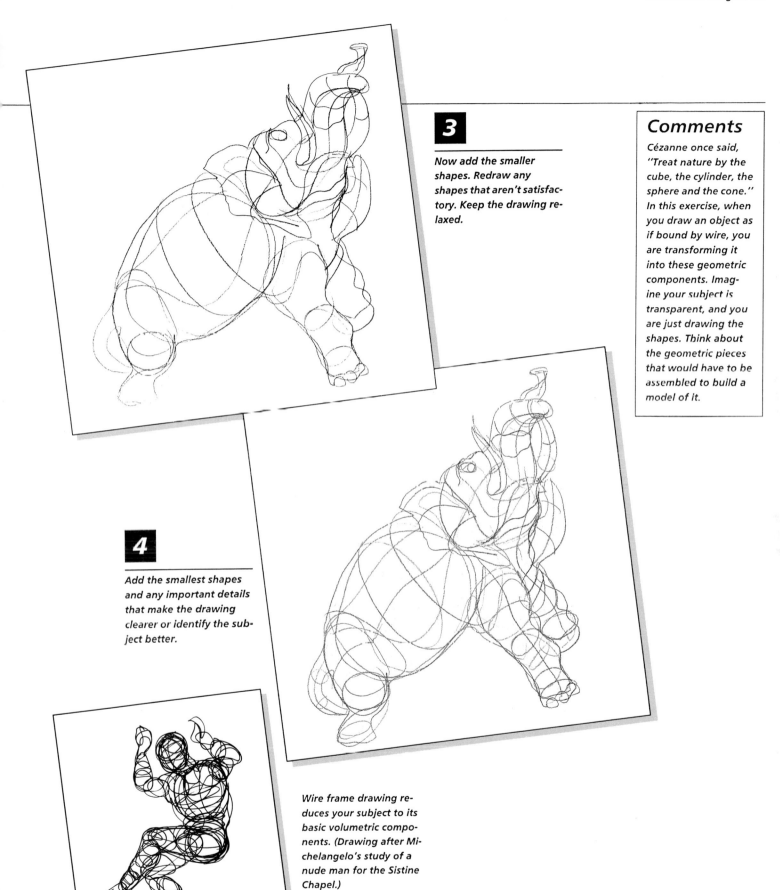

3

Now add the smaller shapes. Redraw any shapes that aren't satisfactory. Keep the drawing relaxed.

4

Add the smallest shapes and any important details that make the drawing clearer or identify the subject better.

Comments

Cézanne once said, "Treat nature by the cube, the cylinder, the sphere and the cone." In this exercise, when you draw an object as if bound by wire, you are transforming it into these geometric components. Imagine your subject is transparent, and you are just drawing the shapes. Think about the geometric pieces that would have to be assembled to build a model of it.

Wire frame drawing reduces your subject to its basic volumetric components. (Drawing after Michelangelo's study of a nude man for the Sistine Chapel.)

Draw the Volumes

Materials
■ One sheet of 18" × 24" newsprint
■ Ebony pencil, with a sharpened point
Time needed: Two to five minutes per drawing

Most objects can be thought of as being composed of smaller, simpler forms. To make your drawings suggest the space-filling nature of your subject matter, you should reduce more complex forms into their simpler parts. In this exercise, you are asked to draw the simpler components that make up your subject in a loose, almost gestural manner. Look for the spherical and cylindrical components of your subjects and indicate them in your drawings.

In this example, a drawing of a plaster cast of a lion cub, shows the round and kidney forms that make up the larger and more complex form.

1

First establish the general shapes of the entire object. Work in a loose, almost gestural style. Don't be fussy. Delineate the larger masses. Look for the "pieces" or building blocks that make up the object. Keep it loose, redrawing any shape if necessary.

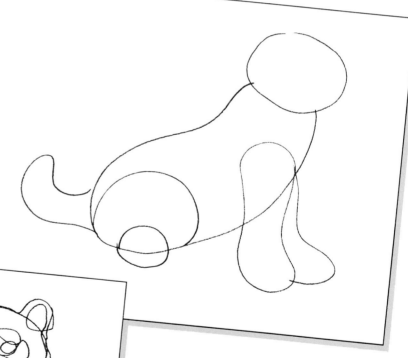

2

Now add the smaller shapes. Redraw any shapes that aren't satisfactory. Keep the drawing relaxed by working in a loose, circular style.

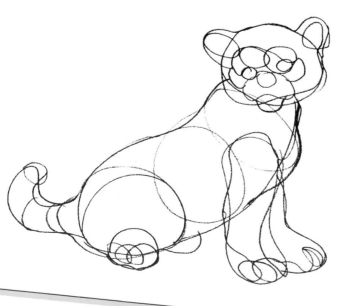

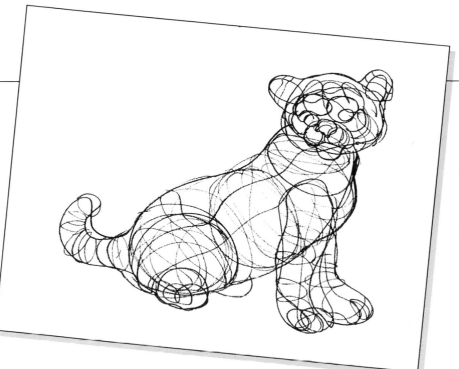

3

Imagine that your pencil is encircling your subject. As you continue to define the shapes on your drawing, think about how the lines express the volumes of your subject. They should create the illusion of the physical space that is occupied by your subject.

4

Add more lines, refining the volumetric qualities of your drawing. Some lines will correspond to "cross contours" and others will appear to wrap around the shapes. Don't worry about overworking your drawing. Keep working until you feel your drawing has a strong sense of the volume, almost as if the object was a hollow, transparent container ready to be filled up.

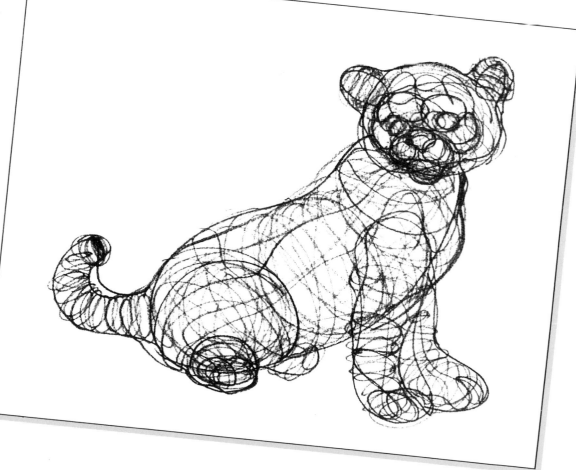

Wraparound Drawing

Materials
- White drawing paper, one 18" × 24" sheet, or
- One sheet of 18" × 24" newsprint
- One stick of soft (6B or 4B) graphite

Time needed: *Five to ten minutes per drawing*

Do a gesture drawing of your subject matter. Dolls, toys and stuffed animals such as teddy bears are great for this drawing. Imagine that your graphite stick is the end of a strand of twine from a ball of twine, and you're going to wrap the object completely in twine. Start at the top and begin "wrapping" the object, as if you were unwinding the twine from the tip of your graphite stick. This exercise works best if you can maintain the pretense that you are wrapping the object. Keep the graphite stick on the paper and keep it moving.

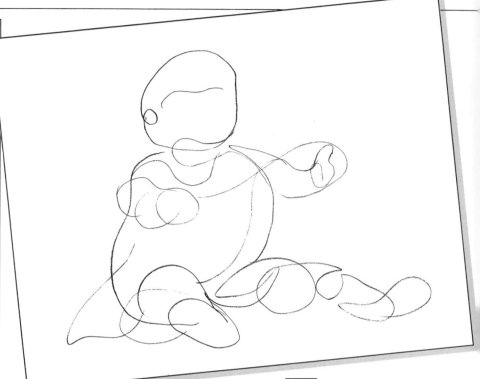

1

Begin with a gesture drawing of your subject. Get the whole thing on the paper. Don't crop any extremities.

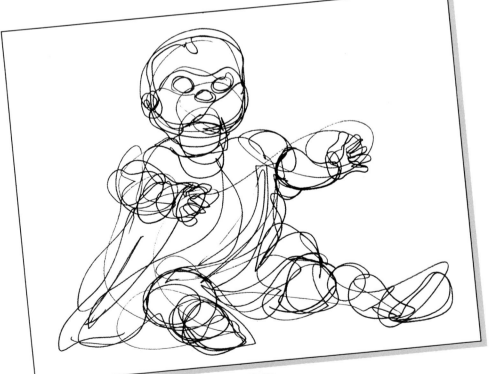

2

Begin "wrapping" the drawing, pretending your graphite is reeling out a continuous strand of twine as you go.

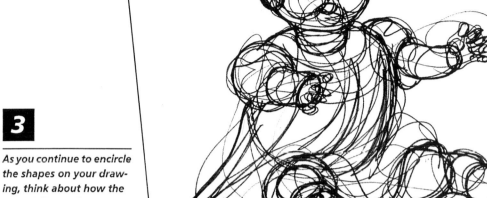

3

As you continue to encircle the shapes on your drawing, think about how the lines define and express the volumes of your subject. It should create the illusion of the physical space that is occupied by your subject.

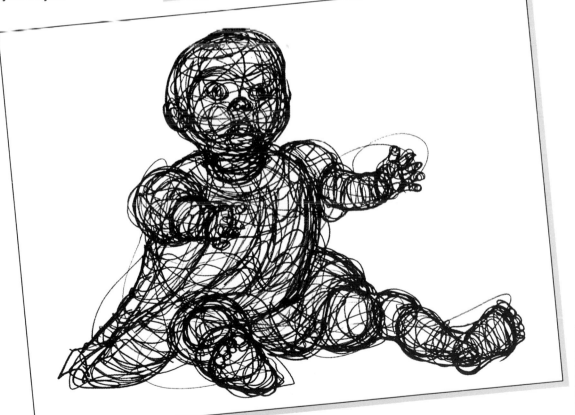

4

Finally, wrap any small shapes you can see. The finished drawing will look a bit like a computer-generated image.

Comments

This exercise could be considered a variation of gesture drawing. In fact, after you do a few wraparound drawings, you might find yourself doing a little "wrapping" when you do any gesture drawing. "Wrapping" something in this way often catches its essential gesture.

Mummy Drawing

Materials
■ White drawing paper, one 18" × 24" sheet, or
■ One sheet of 18" × 24" newsprint
■ One stick of soft (6B or 4B) graphite
Time needed: Five to ten minutes per drawing

This exercise is a wraparound drawing of the human form. Ask family or friends to pose or draw a statue or figurine. Ask your model to sit or stand so you can see the entire pose. Begin with a gesture drawing, and as in the previous exercise, imagine that your graphite stick is a ball of twine, and you're going to wrap the person completely in twine. Start at the top and begin "wrapping." A mummy is an image that obviously comes to mind.

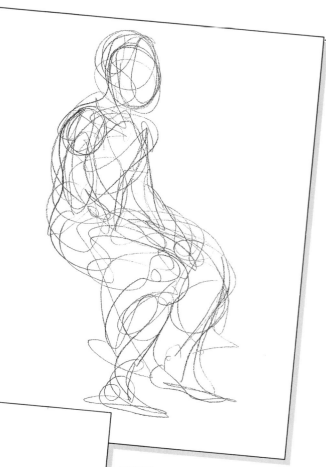

1

Begin with a gesture drawing. Draw the whole figure; don't crop any feet or toes!

2

Begin "wrapping" the figure by encircling the forms as if the graphite line was a long strand of twine, or the binding around a mummy.

Continue wrapping around the various forms of your model, defining the volumes as you go. Your drawing should begin to have a three dimensional look.

Comments

Doing mummy drawings of the figure will teach you much about how the figure is constructed, without the study of anything as complicated as artistic anatomy. The figure is composed of distinct forms that, once understood, can help you draw more convincing figure drawings. A knowledge of how the figure is put together from smaller geometric forms is a good basis for drawing the figure from memory, as in cartooning.

Your finished drawing should show clearly how the body is made up of components or shapes that occupy space. You can identify round shapes, cylindrical shapes, and blocklike shapes in the human body, and your drawing should strongly suggest how each shape takes up a certain amount of space.

Weight and Mass Drawing

Materials
- One soft black litho crayon or one large black crayon
- White drawing paper, one 18″ × 24″ sheet, or
- One sheet of 18″ × 24″ newsprint

Time needed: Ten minutes each

This drawing will begin with some familiar concepts and add one more. The first step is a gesture drawing, no different from the ones we did in Chapter Four. This step will insure that your drawing has a lively energy, even when the gesture is obscured by subsequent drawing.

The second step is the same as in the previous exercise; pretend you're wrapping the figure in yarn. It will give your drawing a sense of volume. In the last step you will fill those volumes up with imaginary "stuff." It helps if you consciously think of yourself as building up the drawing with a material like clay.

Keep scribbling in a gestural manner. Scribble more and darker where the object is heavier, more substantial, massive or bulkier. Imagine that you're a sculptor and are making a clay model, and the crayon is the "clay."

You need more clay where your subject is bigger, and less clay where your subject is smaller. Continue scribbling harder, darker and longer on your drawing where the object is heavier, and scribble less or lighter where it is less substantial. Pretend that you are adding clay to your model as you add more dark lines on your drawing.

In my example, I drew a plaster casting of the male figure. Because it was a sculpture made of a solid hard material, it was easier for me to imagine the sculptural feeling of this exercise.

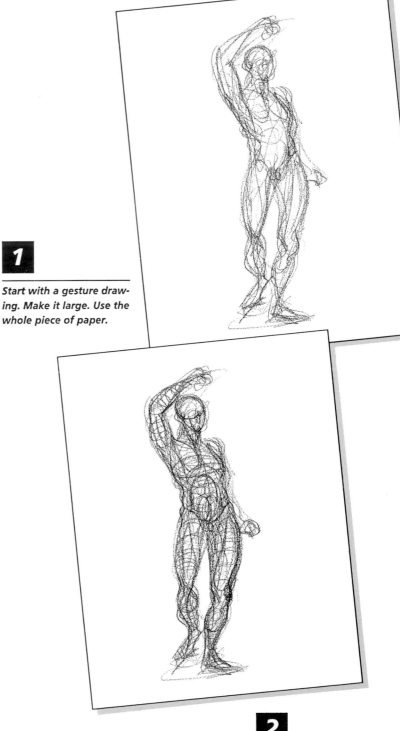

1

Start with a gesture drawing. Make it large. Use the whole piece of paper.

2

Begin "wrapping" the figure just as you did in the previous projects. As you encircle the volumes of your subject, think about how the drawing expresses the way your subject takes up space.

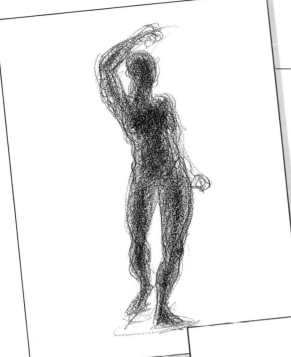

3

Now keep scribbling in the same gestural manner. Continue scribbling harder, darker and longer on your drawing where the object is heavier, and scribble less or lighter where it is less substantial.

 4

As you work, refine the smaller shapes. In the finished drawing, the amount of crayon on your drawing will correspond to the actual distribution of mass on your subject. In other words, the density of the crayon deposit will correspond to the weight or mass of the subject.

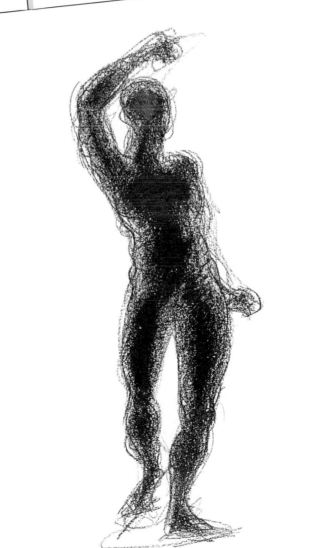

Weight and Mass Drawing

Here are two more examples of the weight and mass drawing. One was done of a plaster cow, the other of a doll. Both drawings follow the same sequence, beginning as a gesture drawing to establish the action, developing into a depiction of the volumes that were "wrapped" and then "filled."

In the final step, the darkness of the deposit of crayon on the drawing roughly corresponds to density of the object, that is, there is more crayon where there is a greater mass of "stuff" in the object.

The real secret to doing a weight and mass drawing is to think like a sculptor. The more vividly you can imagine that you are building or "bulking up" your drawing by scribbling harder and darker, the better. Think of the sculptor building up solid, heavy chunks of clay as he models his statue.

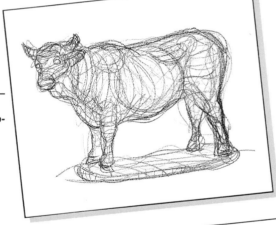

1

Start with a gesture. Remember to draw the whole thing on the paper, capturing the action.

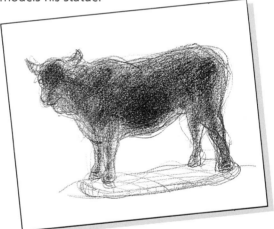

2

Draw the volumes. Think of the wire form and wrap-around drawings.

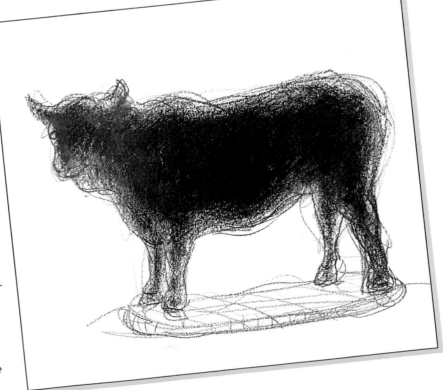

3

Begin scribbling longer and harder to make your drawing darker where it is more massive, thicker or bulkier.

4

Continue to build up the darks of your drawing, making your drawing darker and darker as you think of the relative weights and masses of the various parts of your subject.

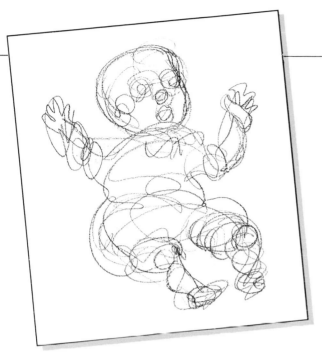

Start with a gesture.

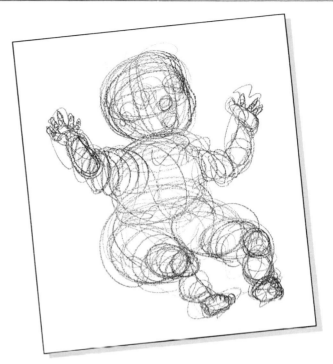

Draw the volumes.

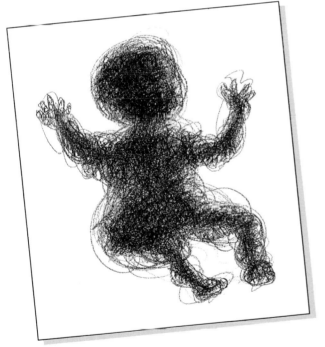

Scribble longer and harder where there is more mass, thickness, or bulk.

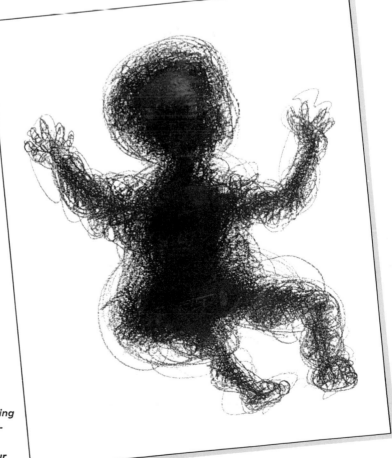

Build up the darks, making your drawing darker according to the relative weight and mass of your subject.

Weight and Mass—The Figure

Materials

■ *White drawing paper, one 18" × 24" sheet*
■ *Ebony pencil, graphite stick, black crayon or black marker*
Time needed: *Fifteen to thirty minutes each*

The most interesting and challenging subject for doing a weight and mass drawing is the human figure. Thinking about the figure in terms of volumes and of mass in this way will give you an understanding of the figure no other drawing experience offers.

Drawing the human form demands an intuitive understanding of its structure. There are good books on how the body works and on human anatomy, and this knowledge is very helpful to the artist. However, there is no substitute for the kind of knowledge that can only be absorbed from actually experiencing the figure through drawings like gesture drawing or weight and mass drawing.

1

Begin with a gesture drawing. Catch the action. Look for the big curves, the disposition of the body's masses.

3

Begin filling in the volumes with matter by scribbling longer and harder where ever the body is thicker, bonier, heavier or more massive. The finished drawing should give a good impression of the body's masses.

2

Delineate the component shapes of the body and identify its constituent volumes.

Weight and mass drawing
can be done in a variety of
materials. This drawing
was done with black
crayon. Soft lithographer's
crayons are also good.

This drawing was done
with a marker.

This drawing was done
with an Ebony pencil.

Chapter 6 Modeling

In the last chapter we began exploring ways of drawing that expressed the almost sculptural mass of your subject matter. In this chapter we will continue to learn ways of describing the physical properties of the things and figures we draw. The basic method we will investigate is called "modeling."

Whenever I use the word "modeling," I mean drawing objects in a way that shows how the object is arranged in space. In other words, how an object takes up space or how its parts are positioned or arranged in space, particularly what parts are closer to you and what is farther away.

We will rely on an arbitrary rule for showing how the parts of an object are arranged in space on the two-dimensional surface of the paper. The rule is simple: If a part of the object is closer to you, it is shown as being lighter in value; if a part of the object is farther away it is made darker. The closest part of the object would be white or almost white and the farthest part would be black. The parts of the object in between these two points will be lighter or darker depending on how close or far away they are.

Now the lightness or darkness of an object is determined only by how close or far away its parts are. It has nothing to do with how the object is lit by the light striking it. It is entirely possible that a part of the object that you're drawing is in shadow, but would still be light on your drawing because it would be closer.

This way of "modeling" a drawing was first taught by Kimon Nicolaides and is described in his book *The Natural Way to Draw*. The rule to make the closer parts of an object lighter and the farther parts darker is just one way to show on paper the disposition of an object's parts in space. The rule could have been reversed: the closer parts could be darker. However, making the far parts dark and the closer parts light makes more sense visually because is it a natural illusion for things to appear darker farther away. Light value things tend to appear closer.

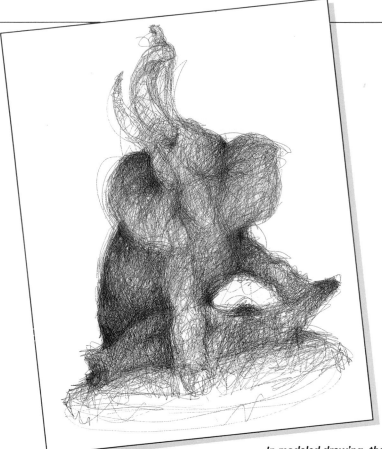

In modeled drawing, the parts that are closer to you are lighter, like the elephant's head and trunk; the parts that are farther away are darker, like the elephant's rear legs.

Another example of modeled drawing. Notice that the effects of light and shadow are ignored.

The rule of modeled drawing is arbitrary. One could make the closer parts dark and the farther parts light, as in this example. However, lighter things naturally tend to look closer, so it makes more visual sense to make the things closer to you lighter.

Comments

One way to think about modeling is to imagine that as you scribble darker and harder on the parts that are farther away, you are "pushing" them back into space.

Another way to think about it is to imagine that you have a miner's lamp on your head and are looking at the object in a totally dark environment, except for the beam of light coming from the lamp on your head. The objects will appear to recede into the darkness.

Modeled Drawing — Graphite

Materials
- *White drawing paper, one 18" × 24" sheet*
- *One stick of soft (6B or 4B) graphite*

Time needed: *About ten to fifteen minutes, depending on the complexity of the subject matter*

The first and simplest exercise in making a modeled drawing should be done with the graphite stick, a tool that you should feel very comfortable with if you used it for the gesture drawings in Chapter Four. This exercise will begin with a gesture drawing, and you should maintain the loose relaxed style of gesture throughout.

Select an object that has parts that extend to the right and left and front and back, such as a doll with the arms reaching out or a stuffed animal. What you don't want is an object that is flat or extends only in one plane. Place the object about eye level at a distance where you can comfortably see the whole thing in one glance.

1
Begin with a large (use the whole piece of paper) gesture drawing. Continue to work in a scribbly, gestural fashion.

2
Keep scribbling, but begin to make the parts of the object that are farther away darker, while leaving the closer parts lighter.

3
Keep scribbling until the most distant parts are about as dark as you are able to get them with the graphite.

4
When you are done, you will be able to see exactly where any part of the object is in relation to any other part simply by noting how light or dark it is.

Modeled Drawing—Ballpoint Pen

Materials

■ *White drawing paper, one 18" × 24" sheet*
■ *Cheap ballpoint pen, the twenty-nine-cent variety, not your expensive type*
Time needed: *About twenty to thirty minutes*

Try a modeled drawing using ballpoint pen on white paper. Follow the same procedure as with the graphite.

The difference between working with the graphite and the pen is the amount of time it will take to make the drawing really dark. You'll notice that the gesture drawing will be rather faint, because the ballpoint pen just can't make the really dark lines that the graphite stick can. Because it takes longer to scribble something with the pen, you'll have plenty of time to make very subtle comparisons about what portions of your subject matter are really close to you.

1

Start with a gesture drawing that is large enough to fill up the page and still get the whole object on it without distortion.

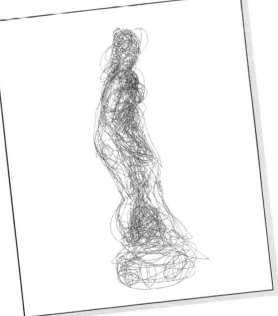

2

Again, scribble more where the forms of the object go back into space. Because the pen makes finer lines, it will take longer to make any one area darker, allowing you time to be very accurate.

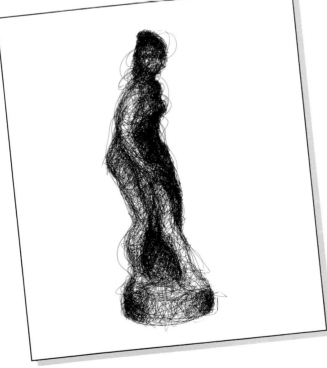

3

The relative placement of the forms of your subject should be clearly expressed in the finished drawing.

Comments

This exercise can become tedious, but it's worth doing a few times so you can see just how precise and fine you can make the distinctions of spatial placement in a modeled drawing.

Modeled Drawing on Gray Paper

Materials
- *One sheet of 18" × 24" gray charcoal paper*
- *One stick of black Charkole or soft (2B) black Conté crayon*
- *One stick of soft white blackboard chalk or soft (2B) white Conté crayon*
- *Kneaded eraser*

Time needed: *Thirty to forty minutes*

In this exercise, you will be doing the same thing you did in the previous exercise, except instead of just making the drawing darker where it is farther away, you can also make it lighter where it is closer. In my example, I drew one of my favorite subjects, a plaster statue of Mercury donning his winged slippers.

In the graphite drawing, you had the opportunity only to make your drawing darker. If an area got too dark, you could not make it lighter. In this drawing, you can also lighten an area that gets too dark too fast. With the graphite on white paper, you could only imagine that you were pushing the drawing back into space. With white and black on gray, you can pull the drawing forward as well as push it back into space. I think it helps if you deliberately and consciously think about pushing back with the black, and pulling forward with the white.

Remember in our discussion of gesture, I asked you to ''always draw the whole thing.'' In modeled drawing, you can't determine how light or dark to make anything unless you compare it to some other part of the object. You should have a mental dialogue that sounds like, ''Is this part of the object closer or farther away than that part? Is that part closer to me? Is the top closer than the bottom?''

I prefer the Conté crayons for this exercise; they are neater and easier to control than the chalk and Charkole, but I also enjoy the softness of the Charkole and chalk and the ease of applying them. They do make a lot of dust, so wear old clothes, apron or smock. Periodically shake the loose dust off the drawing, but don't blow it off so you don't inhale any airborne particles.

Work on a large sheet of gray charcoal paper, and begin by making a gesture drawing with either the white or the black.

2

Once you have the gesture established, keep scribbling on the drawing, using the black to make the parts of the object darker where they are farther away.

Now use the white chalk to make the parts of the object lighter where they come closer. You can scribble the white onto the black or the black onto the white to make all the shades of gray you need to describe the relative position of the various parts of your subject.

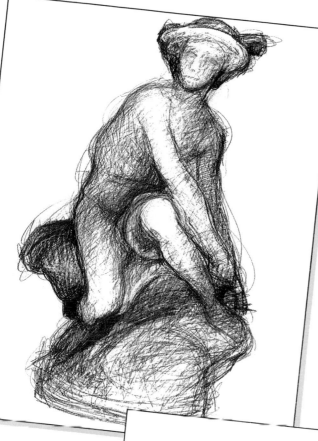

4

Continue adding white or black to the drawing, pushing and pulling the forms closer or farther away. If a part of the drawing gets too dark, simply add more white to bring it forward. If it gets too light, add black.

Using fixative

Any drawing made with charcoal, chalk, dry pastels, or any other powdery material on paper will need some extra care if you wish to preserve it. The most practical way to save your drawing from smearing or from flaking off is to spray it with an aerosol fixative, such as Krylon. Follow the directions on the can, but remember to:

• Apply the fixative in a well-ventilated area, preferably outside or in a room with an exhaust fan.

• Spray evenly using a light coating of fixative, holding the can upright and going from side to side, letting the spray go beyond the edge before the next pass to keep from getting an uneven or heavy buildup on the edges.

• Let the fixative dry before rolling or storing the drawing. If additional protection is needed, apply more than one coat, letting each coat dry before applying the next. Several light coats are better than one really heavy one.

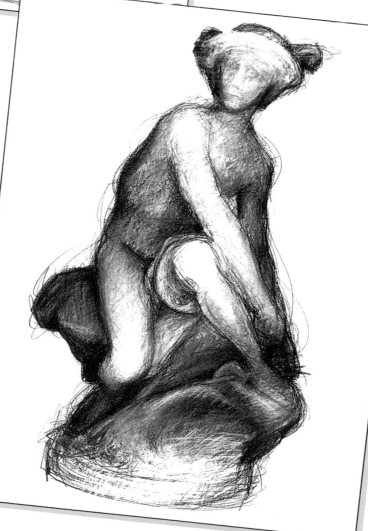

5

You can go over and over the drawing, making any dark lighter by adding white or any light darker by adding black. Near the completion of the drawing, you can use your fingertip, a tissue, or a drawing stump to blend a smoother finish. If you want to save your drawing after you are finished, spray it with fixative.

Modeled Drawing in Acrylics

Materials
- Tube of black acrylic paint
- Tube of white acrylic paint
- ¼" "flat" oil painter's bristle brush
- ½" "flat" oil painter's bristle brush
- Flat nonporous palette, such as a plastic tray, aluminum pie pan, dinner plate, enamelled butcher's tray
- Containers for water
- Roll of paper towels
- One sheet of 18" × 24" gray charcoal paper
- Apron or smock or old clothes

Time needed: Thirty minutes

You will use the black and white acrylic the same way you used the white and black chalk in the previous exercise. My subject is a plaster statue of Socrates in contemplation.

The great thing about acrylic is that it dries fast enough that you can go over and over your drawing. Just like with the charcoal, you can make very subtle adjustments to record how the object is arranged in space.

Clip the gray paper to the board, preferably with a clip at each of the four corners. Begin by painting a gesture drawing with a thin wash of black. Keep the drawing loose and as large as possible without cropping your subject with the edge of the paper.

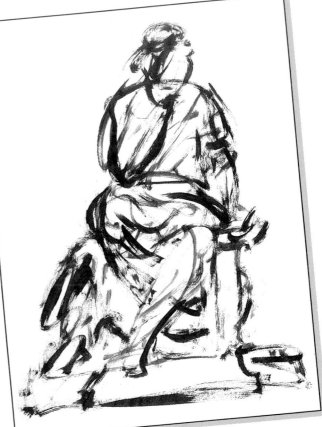

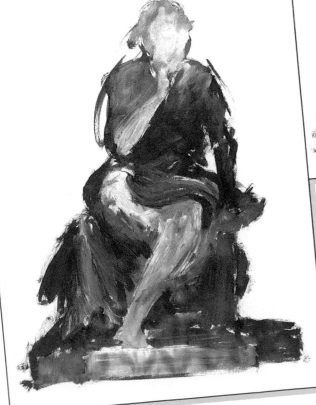

After the gesture is complete, determine what part of your subject is the closest, and what part is the farthest. Paint the closest parts white and the farthest black.

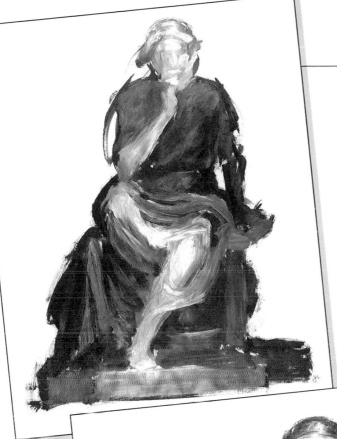

3

Continue painting the parts of the object in various shades of gray depending on how far or close it is to you. All the grays will be of your own making. Cover all the gray paper; none of the paper should be visible inside the object. Because acrylic dries within a few minutes, you need to work steadily to blend wet shades of gray.

Using acrylics

As we will discuss in Chapter Nine, painting is basically the same process as drawing. The only difference is the use of a ''wet'' medium rather than a ''dry'' one. Don't let the fact that you're using paint throw you.

Using paint for a drawing material makes learning to paint a lot easier, and acrylics are an ideal medium to start with. It's inexpensive, cleans up with water, has no harmful fumes, and can be used on paper.

Later exercises will require acrylics, but this exercise in modeling is a good one to start with.

4

Use the smaller brush to make the final details. Acrylic tends to dry a bit lighter than it appears wet. Keep that in mind as you put the finishing touches on your drawing. Because you can work and rework your drawing, it's possible to make your drawing very accurate. All it takes is time, patience, and the willingness to keep looking.

Chapter 7 Composition

Up to now, each project in this book has been a specially designed exercise to give you the right kind of practice for learning to draw. The results you have gotten so far—the drawings themselves—were not the real objective. Your goal was to acquire skill and experience rather than to make good-looking drawings. Granted some of the exercises did produce drawings that were rather interesting, but that was a bonus. Gaining experience and insight have been more important than creating nice drawings. Process has been more important than product.

Now we're going to move a step closer to making Art with a capital A. We're going to add the element of *composition* to our drawings. What is composition? For our purpose of learning how to draw better, we are going to use a very broad definition—any drawing or painting that directly involves the edges of the rectangle upon which you are working. Instead of sticking our subject matter in the center of the paper, with a halo of untouched paper around it, we are now going to begin considering all the shapes that are made when our drawing goes clear to the edge of the paper.

The previous exercises in this book did not result in compositions; they were really "studies." They usually did not involve the edges of the paper. The marks you made were unrelated and unaffected by the rectangle. The paper could have been square or rectangular or even circular, but as long as it was big enough to hold the whole drawing, the actual shape of the paper didn't much matter. From now on, the exercises in this book are going to work with the shape of the paper.

Why is composition so important?

Composition is what makes art out of drawing studies. It is the basis for making a complete, expressive image. Instead of being mainly interested in practicing skills, we will now concentrate on making artistic statements. The product of our labor will now become as important as the process.

One of the great faults in the way drawing is often taught in the schools is the neglect to train the student to think compositionally. The students never get past the "study" stage, never become aware of the rectangle upon which they are working. Then, after a year of drawing they go to a painting class, and are at a total loss when they have to paint shapes and colors that cover the entire rectangle.

Thinking "compositionally"

When I described gesture drawing, I talked about "drawing the whole thing." Whatever your subject was, you were not supposed to crop it off at the edge of the paper, but were to include the whole thing on the paper. You need to be able to make whatever you draw fit the paper.

All too often students get into the bad habit of drawing without regard to size or how things fit onto the rectangle. Since even random cropping often results in an interesting drawing, this is not obviously insidious. This habit, however, prevents the student from acquiring the skill to make their drawings appropriately scaled for whatever size paper or canvas they are working on. If you always attempt to make your subject fit on the paper without any awkward amputations, you will gain control of how your subject will be placed in the composition.

To think compositionally, we still think about drawing "the whole thing" but now we will shift from thinking about the "whole thing" as being the object or figure you are drawing to being the whole composition. When you are creating a composition, draw all that you see in the field of your vision as if it is framed by the edges of the paper. Draw the whole composition right away instead of concentrating on a single object or subject.

The following projects will help you develop an awareness of composition. They will train you to see comprehensively, noticing how objects and the surrounding space must work together to make an interesting drawing. As you become aware of the rectangle upon which you are working, its shape will be an increasingly important consideration in the drawings that you do.

The rectangular shape of the paper is what I call the primal compositional shape. Somehow a composition must engage that prime shape. Any marks or shapes that you make on your paper will change the character of a blank rectangle. If you draw a circle in the middle of the sheet, you have not made one shape but two: a circle and a rectangle with the circle cut out.

*This is a study; a study
does not involve the whole
rectangle.*

*This is a composition. The
lines go to the four edges
of the rectangle, creating
shapes with those edges.*

Three ways of seeing

*There are three ways
of seeing that you
need to learn in these
composition exer-
cises. You need to see
flatly, totally and sim-
ply. If you can keep
these ideas in mind
until they are a perma-
nent part of your
thinking habits when
drawing, you will see
a tremendous differ-
ence. By drawing
flatly, I mean looking
at three-dimensional
forms and drawing
them as flat, two-di-
mensional shapes as
described in Chapter
Two. By drawing to-
tally, I mean drawing
the big picture first
while leaving the de-
tails for later. You
must "draw the whole
thing" right away,
getting the large
shapes and patterns
of the entire composi-
tion down on your pa-
per. By drawing sim-
ply, I mean simplifying
all the subtle changes
and differences to the
most telling and sig-
nificant ones, ignor-
ing all the surface de-
tails, variations, and
embellishments. Re-
member: Draw flatly,
totally and simply.*

Radiating Line Contour

Materials
- One sheet of 18" × 24" newsprint
- Ebony pencil

Time needed: About fifteen minutes

Put an object on a stand where you can see a lot of the background — the stuff in the room behind it or whatever is in the backdrop. Now make a blind contour of the object's silhouette edge. Then, look at the edge and notice where the background lines appear to intersect the edge. Do a blind contour of the lines starting *at the edge of the object*. Say to yourself, "OK that line of the window appears to begin right above the teddy bear's ear" and draw the line until it runs off the page. Do all the lines you can see originating on the silhouette contour edge.

1

First make a blind contour of the object's silhouette edge.

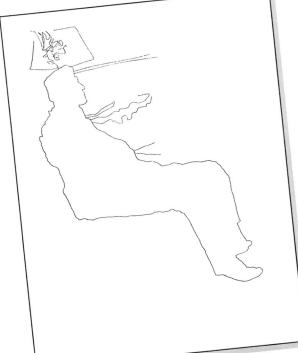

2

Do a blind contour of the lines around the object that appear to touch the object, starting each line at the edge of the object.

3

Continue drawing all the lines you can see around the object. Include all the lines you can see in the background. The finished composition will have an empty shape in the center, with background lines radiating from it.

Draw the Background First

Materials

- *Ebony pencil*
- *One sheet of 18" × 24" newsprint*

Time needed: *About ten minutes*

In this project, you will draw a contour of the background of your composition first, then place an object in front of it and draw its contour *over* the background.

Situate your drawing board so you can draw a relatively complex background, perhaps a room interior or a window, and then do a quick contour or a sneak-a-peek contour of it. Next, pose someone or put an object in front of you so you can see it against the backdrop you just drew, and do a contour drawing right over the lines of the first step.

Consider using a marking pen or a colored pencil for the object's contour to make it stand out clearly from the background drawing

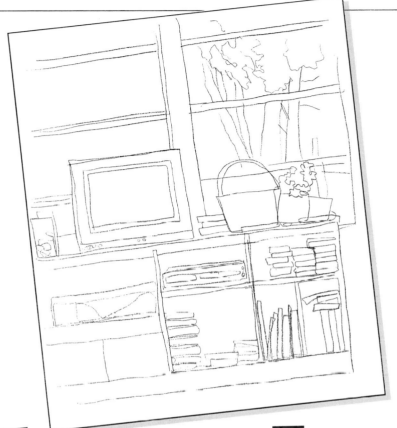

1

First do a contour drawing of the background. A complicated one works best.

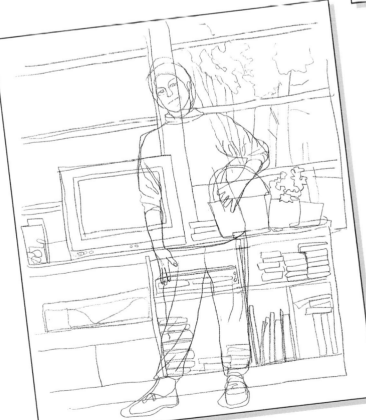

2

Pose your model or place an object against the background and draw the contour, superimposing it right over the background.

Comments

In Chapter Two, we talked about using the background grid as an aid to copying the shapes of things accurately. In this project, the background drawing forms an irregular grid against which you measure the exact shape of the object you are drawing.

Assemble a Still Life

Materials

- *Ebony pencil*
- *One sheet of 18" × 24" newsprint*

Time needed: *About twenty minutes, depending on the complexity of the objects*

In this project, you will literally assemble your still life as you draw it. Select two or three objects and place them on a table or stand and draw a contour of them. Find another object, place it with the others, and draw it on the same drawing. Add another object, and draw it. Continue adding more and more objects until the composition is full. Notice how the shapes of your drawing interlock. Watch how the lines around each shape help define the shapes around it.

1

Draw two or three still life objects.

4

5

2

Add another object and draw it.

3

Continue adding more objects and drawing them one by one until your drawing is complete.

6

7

Stop when you have drawn everything in your field of vision as limited by the edge of the paper.

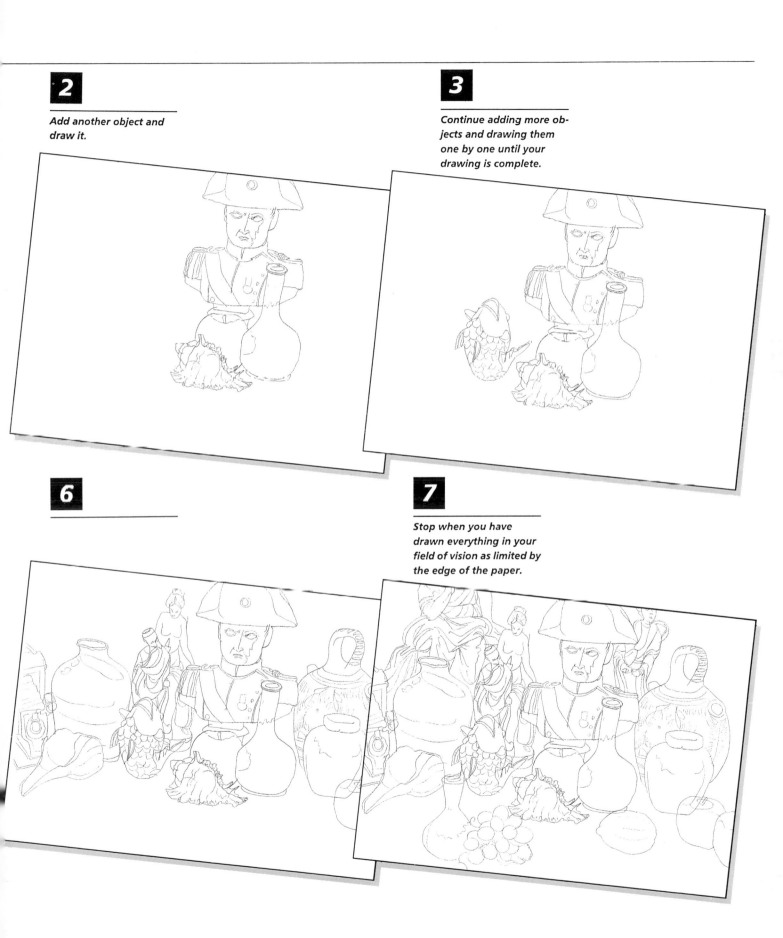

Contour Composition

Materials

- Ebony pencil
- One sheet of 18" × 24" newsprint or white drawing paper

Time needed: Ten to twenty minutes for each drawing

The essence of a contour composition is taking the lines to the very edges of the paper. The idea can be applied to any subject matter. In each of these examples, the entire rectangle was filled with contour lines. The entire environment was drawn in each.

Build a contour composition by relating each component to the others as you draw. Draw each piece with an awareness of how its shape augments those around it. Build your drawing, piece by piece, until you have filled the entire rectangle.

Your drawing can be a sneak-a-peek contour, a quick contour, or a blind contour. If you vary the kind of contour drawing, it will enhance your skill more quickly as well as provide variety. I recommend you do contour compositions periodically to keep your skills sharp.

Comments

This project takes you a step toward making sketches for paintings. Quick contour in particular is an ideal method for developing habits of vision that embrace all that is included to your complete field of vision.

Work slowly and carefully, feeling the contour with your eyes as you do with all contour.

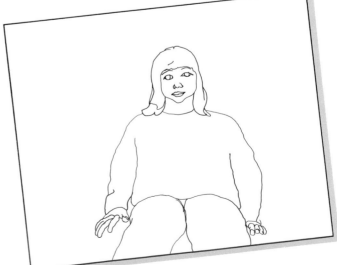

2

Work at seeing how all the shapes fit together into a larger whole.

3

Keep drawing until you come to the edges of the paper and have included everything you can see within your field of vision.

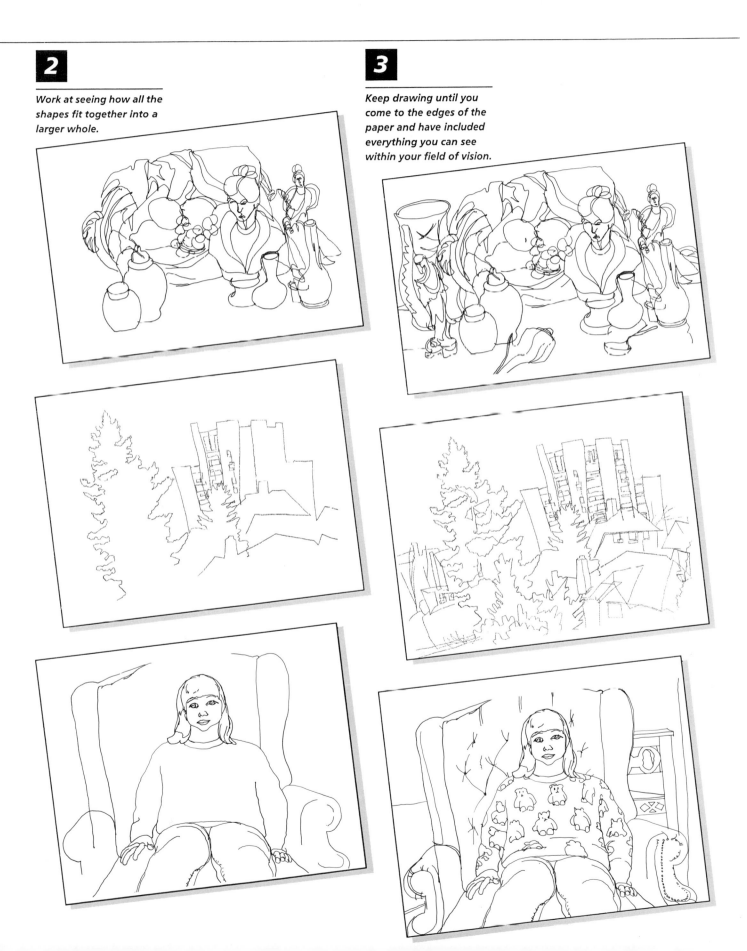

Gesture Composition

Materials

- *One sheet of 18" × 24" newsprint or cheap paper such as blank scrap paper or used computer printout paper*
- *One stick of soft (6B or 4B) graphite*
- *Sketchbook*

Time needed: *About five to ten minutes each, depending on the subject matter*

This is a very simple variation on the extended gesture drawing that we did in Chapter Four. Instead of drawing just one thing, you're going to do a gesture drawing of everything that you can see around it, just as you did in the contour compositions. Try at least two or three still life arrangements, interiors and landscapes.

The setting or environment is an important part of these drawings, so give it some thought. What you draw is part of the expressive statement your drawing will make and an opportunity for creative thinking.

Remember, you are not making studies. You are making compositions. Just as you don't draw a gesture of something by drawing all the little pieces without a sense of how they are connected, don't draw a composition by drawing all the separate objects.

Comments

Each gesture composition should use the whole piece of paper. The scribbles should go to all four edges. Try not to noodle in the center. Involving the edges makes it a composition and not a study.

1

Make the gesture now not of a single thing, but of the whole arrangement.

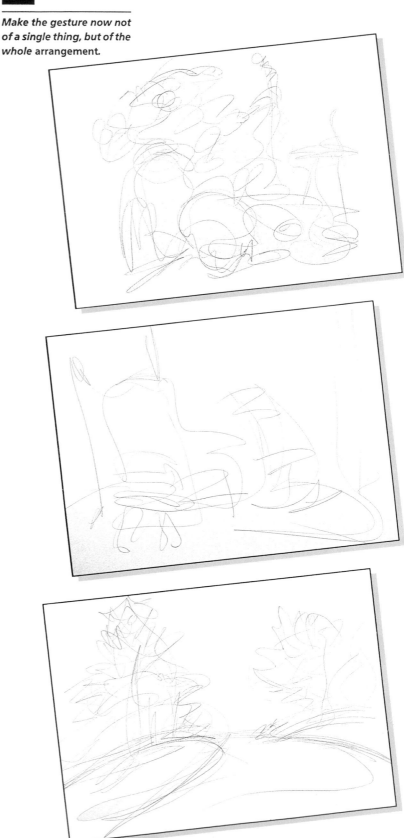

2

Then draw whatever else you can see that will fit on the paper.

3

Once you have established the underlying shape of the whole arrangement, you can embellish the separate elements.

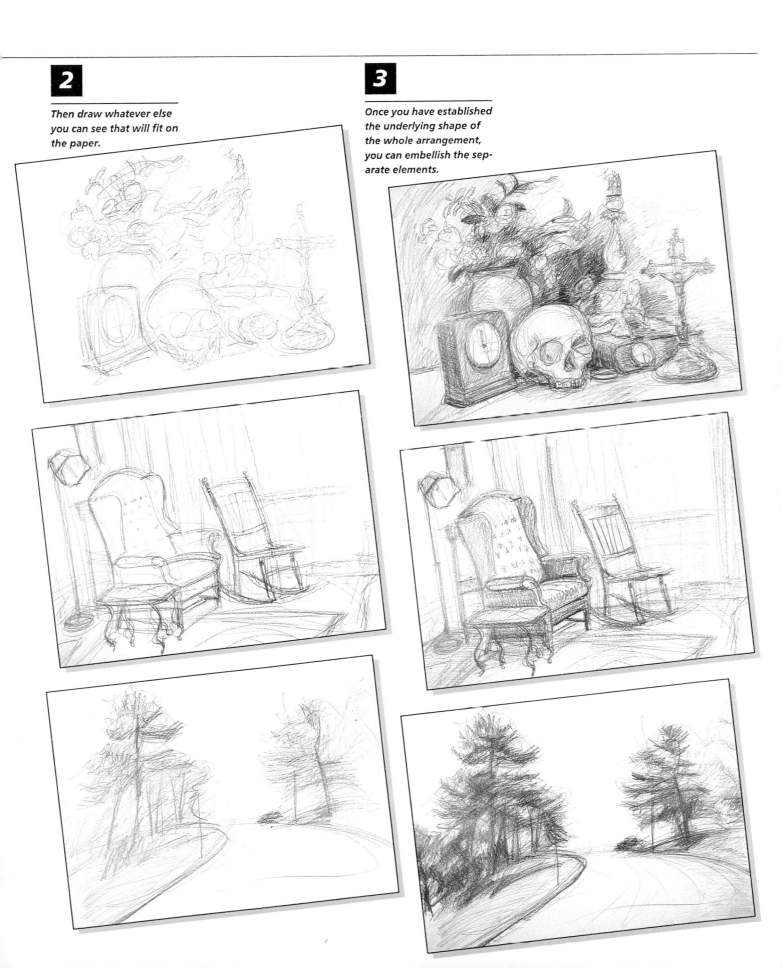

Simple Shape Composition

Materials

- *One stick of soft (6B or 4B) graphite*
- *One sheet of 18" × 24" newsprint*

Time needed: *No more than five minutes for each drawing*

Often, when we draw, we are too smart for our own good. In other words, we try to be smart when we draw by making a good drawing that looks like what we see with all the details in the right place in correct proportion. But in the process of perfection, we lose sight of the underlying structure or composition. Naturally enough, we end up with a drawing that is missing something. All the pieces look right, but the whole thing doesn't look unified. It's "not together."

This exercise is designed to give you practice in seeing through all the surface detail all the way to the underlying pattern of basic shapes of which your drawing is composed. For your subject matter, assemble a still life or an interior or landscape, and draw it by reducing whatever you are looking at into no more than five or six large simple shapes and maybe five or six smaller ones. Each shape should be a closed shape. Ignore all detail.

Draw all the shapes you can see all the way to the edge of the paper. When you are done, count every shape in your drawing. If you counted more than twenty shapes you have drawn too many.

This drawing should only take about five minutes. If it takes longer you might be trying too hard.

Reduce your subject matter to the underlying pattern of a few large, simple shapes.

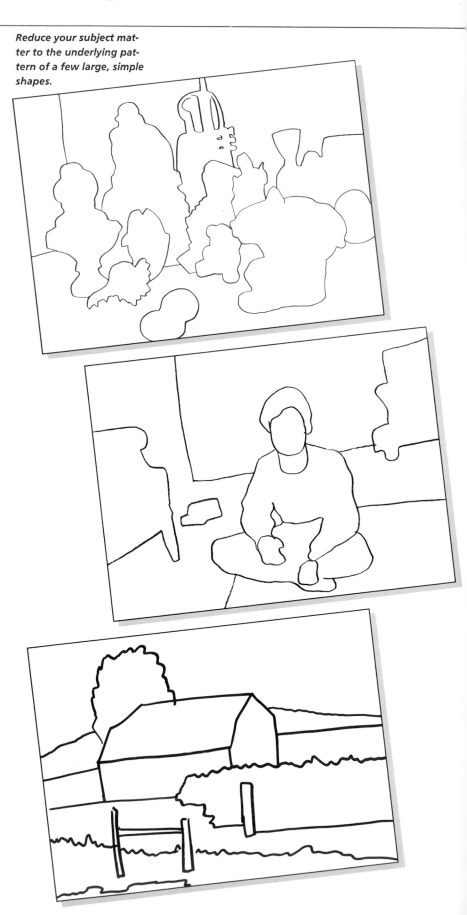

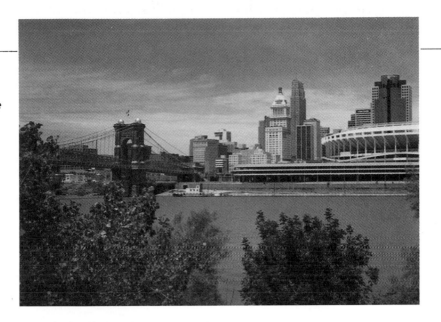

Here are some photographs you can use to practice doing simple shape compositions. The next step is to do them from life.

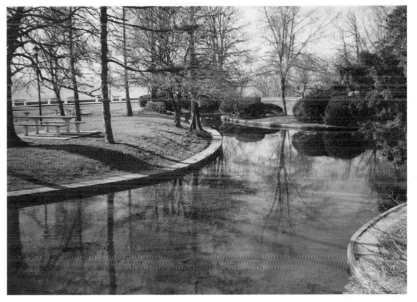

Comments

When I demonstrate this drawing to my students, I call this exercise the "dumb" composition. I make little effort to make the shapes very accurate, hence the almost simpleminded "dumb" quality of the resulting drawing. I deliberately keep it simple. It is a very loose, relaxed recording of only the major shapes that I see.

It is a lot harder to ignore details and concentrate on the big shapes than to focus on all the colors and details of your subject matter, but it is this process of seeing through to the big shapes that will make you aware of the composition. Composition is not in the details; it is in the underlying arrangement of big shapes.

The first step in several subsequent exercises will start with these very simplified "dumb" compositions.

Chapter 8 Tonal Values

If there were only two concepts that you should remember to make better drawings, it would be *shapes* and *values*. If you can draw the right *shapes* and then make them the right *values*, you will have learned to draw. It is that simple (but not always *that* easy!).

We discussed looking at *form* and drawing *shapes* in Chapter Two. In this chapter, we will begin learning about tonal *values*, which are simply the lights and darks in your drawing. If you are working with a drawing medium that makes blacks and shades of gray, you are working with tonal value. A black-and-white photograph is an image that also only shows tonal value. All the different colors have been changed into grays; in other words, the spectrum of colors is rendered as a gray scale of different grays.

Learning to work with tonal values involves two different things. First, you have to learn how to see colors but interpret them as shades of gray on your paper, the way black-and-white film does. Second, you have to then adjust and modify those values so your drawing is both clear and interesting.

To begin, we need to think about one of the properties of color. Color has three dimensions:
• *Hue* — its identity as yellow, red, blue, etc. — in other words, the color name;
• *Intensity* — its relative brightness and clarity or dullness;
• And finally, color has *Value*.

Some colors are always lighter in value than others. For instance, on the spectrum of colors as seen through a prism or in the rainbow, yellow is lighter than red, but red is lighter than purple. Any two colors can be compared to see if one looks lighter than the other in this way.

When translating the colorful world we see into values, you need to identify the lightest color and make it white or near white in your drawing, and identify the darkest color and make it black or near black. All the other colors will then be rendered as lighter or darker grays in a range or scale between the lightest and darkest.

The key to this process of rendering color into value is a constant comparison between any two areas of value. This becomes automatic very quickly and requires little conscious thought.

In the following exercises, you will practice looking at colors and translating them into various shades of gray. However, since our eyes see more subtle differences in color than you could ever hope to reproduce exactly with any drawing materials, you will need to do more than just copy the values you see.

You will have to make changes in the values you see to make your drawing clearer and more appealing. Some darks will need to be darker than they actually appear, and some lights will have to be lighter.

Your goals in adjusting the tonal values are: to make the drawing clearer; to enhance the illusion of depth; and to strengthen the composition. Let's look at each in turn.

Make your drawing clearer

The key to all of these goals — clarity, depth and strong composition — is *contrast*. Wherever two shapes are adjacent, there should be sufficient tonal value contrast to make it clear which shape is which, or which shape is in front of the other. If two adjacent shapes are drawn with the same or close to the same values, the contour edge

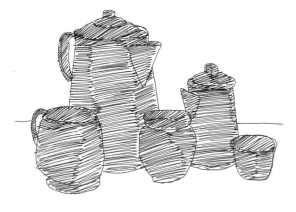

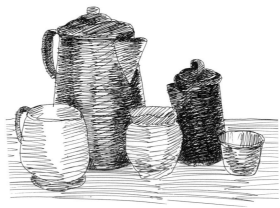

The drawing on the far left is confusing because shapes of the same value are adjacent. The one next to it is clearer because there is a distinct contrast along adjacent contours.

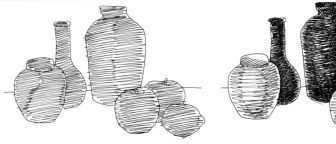

between them will be very difficult to see. The two shapes will appear to merge as one, with the strong possibility that it will be very confusing to the viewer.

In nature, or in the subject matter you are drawing, you may often see two forms that are very similar in value, but differ in color and texture. These differences make it easy for the eye to distinguish the shapes. However, if you render them as shades of gray in your drawing, you won't have color or texture to make the differences easily seen *unless* you alter the values.

Remember this rule: *Contrast at the contours creates clarity.*

Which shape you alter depends on many factors, but it is often an arbitrary choice. One or the other has to be lighter or darker for the sake of clarity. Your decision may be based on reasons given below on enhancing depth or strengthening the composition.

The drawing above lacks depth because the shapes are the same value. The one on the right has the illusion of depth because the more distant shapes are darker.

Enhance the illusion of depth

The tonal values in your drawing will also greatly affect the illusion of depth that you create. You may remember from the modeled drawings described in Chapter Six that darker values seem to recede into the distance, while lighter ones appear to advance. Although there are many exceptions, you can apply this general rule to the tonal values in your drawing. If you want to create a strong illusion of depth, make the closer things lighter and the farther things darker.

Following this rule will help you decide what shape to make a little darker on your drawing when you see adjacent forms with very similar values. Make the shape that you want to appear farther away darker.

Strengthen the composition

Finally, tonal values play a major role in the composition of your drawing. Tonal values will largely determine how your drawing will be seen by the viewer. The pattern of lights and darks will determine what part of the drawing is seen first, and what parts will attract and retain the viewer's attention.

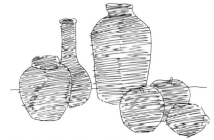

The drawing above lacks interest because there is no value contrast. The one on the right is more interesting because it has a definite focal point—the apples on the right, the area of greatest value contrast.

Gesture Value Study

Materials

■ *One sheet of 18" × 24" newsprint or white drawing paper*
■ *One stick of soft (6B or 4B) graphite or Ebony pencil*
***Time needed:** About five minutes or less for each drawing*

This is a simple but important variation on gesture drawing. The first step of the exercise is a gesture drawing, no different from those presented in Chapter Three. You still draw ''the whole thing'' while depicting the action or energy that you sense in your subject, in a loose, almost scribbly style. However, instead of stopping when you feel that you have captured the subject's gesture alone, you continue to scribble in the smaller details while scribbling those areas that are darker in color or in shadow. Keep working until you have accounted for every dark and light you can see. Constantly compare the values you see. Unlike the modeled drawings where the lights and darks were determined by an arbitrary rule, this drawing will be light where you see your subject as light and dark where you see it dark.

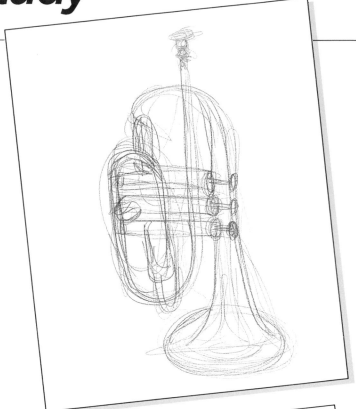

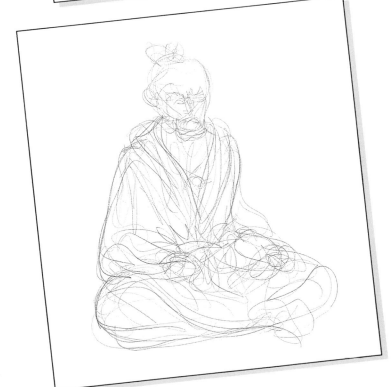

1

Start with a loose, complete gesture.

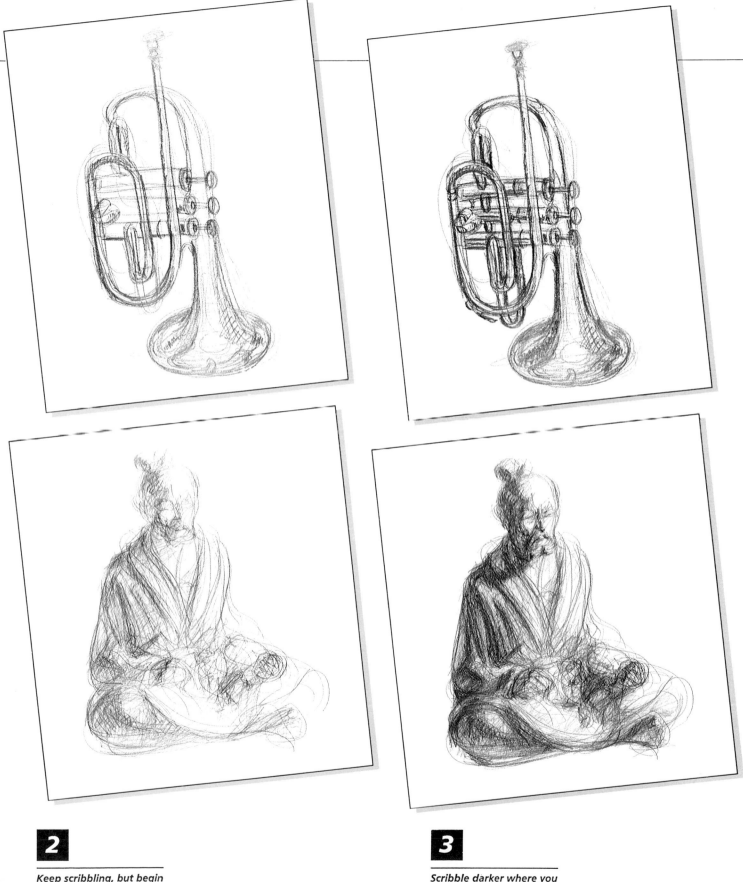

2

Keep scribbling, but begin to add details and further refinements.

3

Scribble darker where you actually see darks and leave light the areas that are illuminated or are lighter in color.

Gesture Value Composition

Materials
■ *One sheet of 18" × 24" newsprint*
■ *One stick of soft (6B or 4B) graphite or Ebony pencil*
Time needed: *About ten minutes per drawing*

This exercise is an obvious variation on the extended gesture and the gesture composition we did in previous chapters. The first step of the exercise begins as a gesture composition. You still draw the whole thing, i.e. the entire scene included in your frame of vision, in a loose gestural style. However, instead of stopping when you feel that you have accounted for the entire scene, you continue to scribble in the lights and darks that you see. How much you include in your drawing depends on how much time you want to devote to the drawing. The longer you work, the more developed and detailed your drawing will be.

This is one of the most effective ways of honing your skills. It is relatively quick and simple, yet involves the most important concepts of drawing, with the exception of contour. It gives you practice in drawing what you see accurately; it sharpens your ability to see shapes and to simplify them; and it improves your ability to render color and light as patterns of value.

The values you see are created by both the color of the object and the lighting situation in which it is seen. The actual colors of the object when rendered as shades of gray are called the *local* (or *home*) values. The value pattern you see is created in fact by the juxtaposition of the pattern of light and shadow onto the pattern of local value.

Doing gesture value compositions are such good practice that they should become part of your regular drawing routine. In fact, they should be part of a lifetime of drawing. Gesture value studies are ideal ways of drawing in your sketchbook.

1

Begin with a gesture of the whole composition. Account for all you see within your field of vision from the beginning.

2

Develop the drawing by adding more details, but don't lose sight of the overall gesture.

3

Begin scribbling the darks you see, both dark colors and shadows.

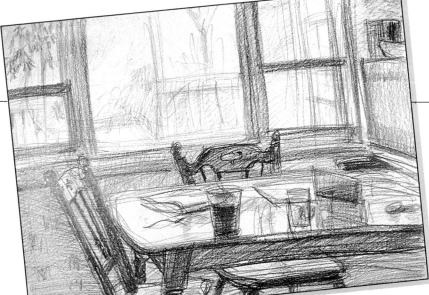

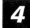

Continue scribbling in more darks and details until you have reached the level of completeness you desire.

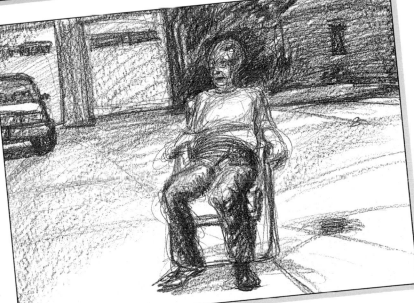

Here are two more examples of gesture value compositions.

Value Pattern Sketch

Materials
- ■ *Ebony pencil*
- ■ *One stick of soft (6B or 4B) graphite*
- ■ *White paper*

Time needed: *Thirty to sixty minutes*

In this exercise, the focus is on the overall pattern of lights and darks in your subject matter. Every composition can be reduced to a flat pattern of lights and darks, and the artist must be aware of and sensitive to this pattern because it is the foundation of his picture's design.

However, it is not easy to identify and draw just the lights and darks because of the habit of seeing and wanting to draw things as *objects*. The left side of the brain naturally pays attention to the identity of what you are looking at as separate objects; it has no use for the tonal value pattern. But it is the tonal value pattern that is critical to the success of your drawing. As an artist, you should cultivate the habit of noticing the pattern of lights and darks independently of the identity of the objects.

Color must be ignored as well. Two objects, side by side, one blue, the other green but of the same value, may need to be considered as one big dark shape. In this exercise, you are going to make small sketches of your subject by drawing *only* the lights and darks. Don't draw contour lines as boundaries of objects.

Like an out of focus photographic slide projected on a wall, your sketch should simply be a rough or generalized record of the overall pattern of lights and darks. It may help to look at your subject and *squint*.

In fact, your internal dialogue as you draw could sound like, ''There's a large dark shape over here, and a light one over there, and here's a middle gray shape under that shape.''

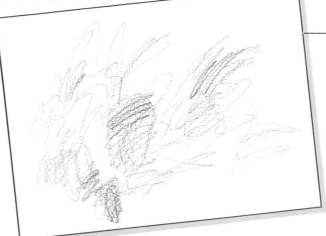

1

Begin with a loose gestural indication of the entire arrangement of your composition.

2

Scribble the lights and darks that you see. Don't draw distinct edges. Think of your subject matter as one big pattern of lights and darks.

3

Develop the drawing without outlining everything. Resist the urge to define edges. In the last moments of your drawing add only those details (and yes, edges, finally), that clarify your drawing. Be selective.

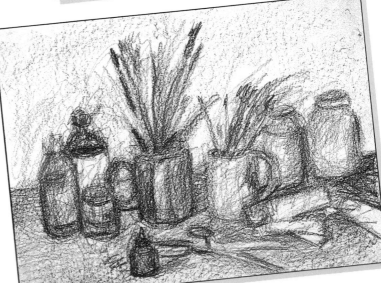

Gesture Value Sketch

Materials
- *One stick of black Charkole*
- *White paper*

Time needed: *Thirty to sixty minutes*

This is the same exercise as the previous one, except it is done with Charkole rather than graphite. Use a one-inch-long piece of the Charkole on its side to make the darks in your drawing. Draw the lights and darks directly, without outlining everything first. Look for the overall pattern of lights and darks and draw *that*, not the separate objects. Include only those details and edges that really make for a clearer, more attractive drawing. Don't overwork it.

Squinting is a very useful way of studying the overall value pattern of your subject. Squinting eliminates the details, making it easier to see the larger pattern of flat shapes of value.

As many artists have pointed out, there are very few real lines in nature. What we render as lines on our drawings are only edges and borders, abrupt value changes and coloration. Nevertheless, we are in the habit of seeing these as lines, and it is sometimes difficult to recognize their true nature.

This is a difficult exercise to do in the sense that it does not offer us the familiar and comfortable net of lines that we use to build and organize our drawings. It forces us to see things as a pattern of shapes of values. We must behold the larger pattern rather than looking at the details.

Tonal value drawings without lines are real workouts for the right brain!

1

Begin with a gesture of the entire composition. Think about drawing the bigger pattern.

2

Use the side of the Charkole to make broad strokes. Don't draw distinct edges. Don't draw one object or element at a time.

Refine the drawing, clarifying the shapes, adding smaller shapes.

Value Composition in Ink

Materials
- Ebony pencil
- Bottle of black India drawing ink or black writing fluid
- Small cup or container for mixing ink washes
- Large container of water to clean brush
- White drawing paper, one 18" × 24" sheet
- No. 6 bamboo brush

Time needed: Fifteen minutes

This project is like a paint by number. First make a "simple shape" composition as in Chapter Seven, with about fifteen to twenty shapes. You could make this drawing with a small brush dipped in ink, or with a sharp Ebony pencil, or a waterproof black marker. Work in a quick contour style, simplifying and reducing the shapes until you have no more than twenty in your drawing. Keep it simple. Make each shape a completely closed one, with a continuous edge all around.

After you have made your drawing, use your pencil to lightly label all the little shapes according to this scale: 0 = white, 1 = light gray, 2 = middle gray, 3 = dark gray, 4 = black. You will have to make some judgment calls on many of the shapes, but try to make the numbers correspond to the overall relationship of the values you see in your subject.

Since your eye sees thousands of shades of value, you will have to simplify. When two shapes of the same value butt together, you can make a dark contour line between them, but try to avoid it if possible.

After you have labeled all the shapes, mix washes of ink to correspond to the four degrees of gray and simply fill in the shapes with the appropriate wash. Notice that you will work from light to dark.

1

Make a "simple shape" composition as you did in Chapter Seven. Work in a quick contour style, simplifying and reducing the shapes.

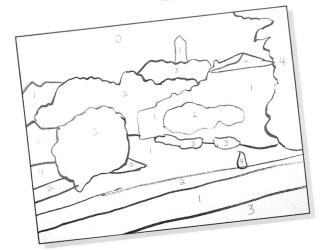

2

Label the lightest shapes you can see 0 for white; label the darkest shapes you can see 4 for black. Label all the other shapes 1, 2 and 3, depending on how close they are in value to light gray, middle gray and dark gray.

3

Now mix a rather dilute wash in your small container by adding a little of the ink to a small quantity of water. Test it on the corner of the paper. It should dry to a very light gray. This will be value 1. Then paint the entire paper with this very light gray except the shapes you marked 0 for white. There is no point in painting all the little shapes separately. Let it dry.

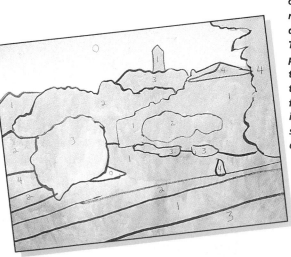

4

Now add some more ink to your wash and test it. It should dry a middle gray. This is value 2. With this wash, paint the entire drawing except those shapes numbered 0 and 1. Let it dry.

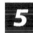

5

Add some more ink to the wash to make a dark gray and paint all the remaining shapes numbered 3 and 4. Don't paint shapes numbered 0, 1 and 2.

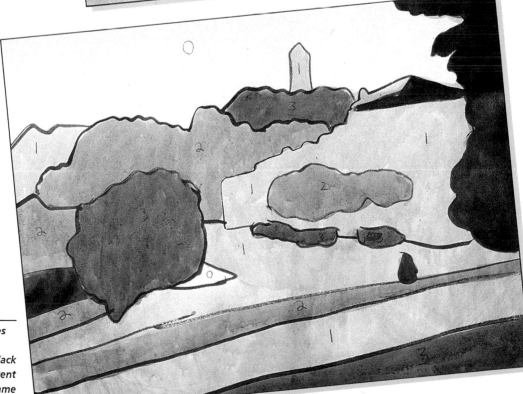

6

Finally, paint the shapes numbered 4 with pure black ink. Paint a thin black line between any adjacent shapes that have the same number.

Ink Wash

Materials
- Bottle of black India drawing ink or black writing fluid
- Small cup or container for mixing ink washes
- Large container of water to clean brush
- White drawing paper, one 18″ × 24″ sheet
- No. 6 bamboo brush

Time needed: Twenty to thirty minutes

This exercise is similar to the previous one, but here we'll dispense with the preliminary drawing and labeling the shapes with a value scale number. In this project, simply use the ink to make a value composition, building up the darks by adding darker and darker washes.

This project works best if you work in a rather carefree manner. It is impossible to fully control the ink, so you must be open to the material's fluid and unpredictable nature. Let it drip and run, guiding the flow of the ink with the brush rather than trying to control it.

This project can be messy, so protect nearby surfaces from splashes and wear old clothes.

Start with a loose, light, brush gesture drawing of the entire composition.

Begin painting the light gray shapes first. Leave the areas that are white untouched. You can slosh the light gray into areas that will later be painted over with a darker tone, but you need to be careful around the edges of the white areas because you can't recover the white of the paper.

After establishing the lights, mix more ink into your wash. Test it first to make sure it will make a good middle gray. Now paint all the areas that will be middle gray or darker. Continue to add more ink to your wash and paint in the darks. Don't be afraid to make your darks really dark. Finally, use the ink full strength to add black details. The strength of the composition will depend on a good use of the whole range of values. You may need to add black lines where two dark value shapes are butted against each other for clarity.

1

Use the tip of the brush and a dilute wash of ink and water to make a loose, light, gesture drawing of the entire composition.

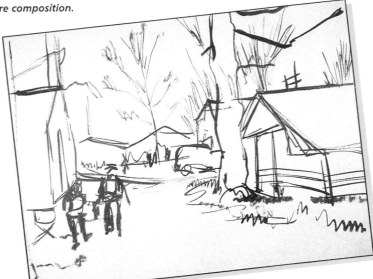

2

Paint in the shapes of tonal value with the light gray shapes first. Be careful around the edges of the white areas because you can't recover the white of the paper.

3

Now paint all the areas that will be middle gray or darker. Finally, use the ink full strength to add black details.

Value Studies of the Masters

Materials

■ *Charkole or any drawing materials that you feel comfortable with*
Time needed: *About five minutes for each drawing*

A highly recommended way to learn about tonal values is to make studies of paintings by the great masters. The great painters of the seventeenth to the nineteenth centuries were masters of using lights and darks to describe form and space and masters of making spellbinding compositions.

Go to the library or bookstore and find books with good color reproductions of master painters. Rubens, Rembrandt, Caravaggio and Poussin are good ones to start with. Make small value sketches in black and white based on the most attractive or interesting pictures. Notice how the artist used contrasting values to direct your eye through the composition. Study how the artist used hard and soft edges to define form and articulate spatial depth.

View of Delft *by Jan Vermeer.*

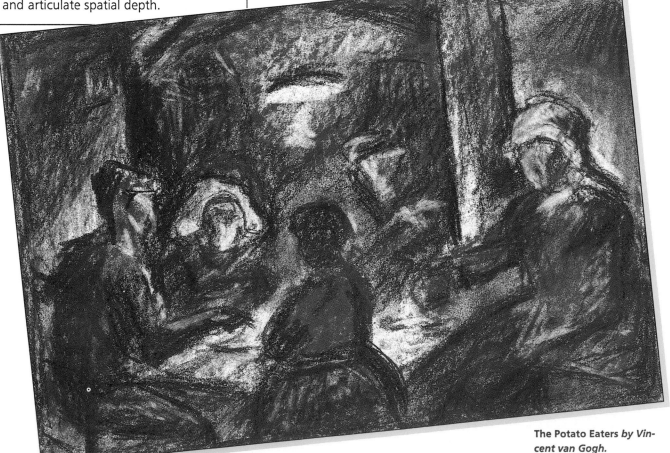

The Potato Eaters *by Vincent van Gogh.*

Calling of St. Matthew *by Caravaggio.*

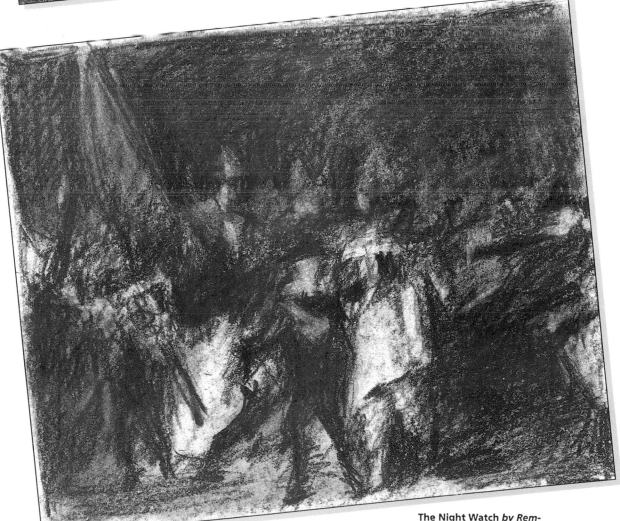

The Night Watch *by Rem-brandt.*

Chapter 9 Drawing for Painters

Many beginning painters enthusiastically take brush in hand and begin painting without giving any time or even thought to developing drawing skills first. Often the result is frustration and failure. After doing the exercises in this book, especially if you practice regularly, you will already have an impressive foundation for learning to paint. If you already paint, you should notice a considerable improvement in your painting.

Unfortunately, many students manage to forget everything they learned about drawing when they step up to an easel to paint. Working with colors and unfamiliar, expensive materials and equipment often completely erases all the skill and knowledge about picture making that they gained from drawing.

Fortunately, good painting is really a matter of good drawing. There is no significant difference between creating an image with charcoal or creating one with paint. Neither is any harder or easier than the other. All that you learn about good drawing can be applied to painting. If you can draw well, you can paint well.

There need be no dramatic break between learning to draw and learning to paint. All that you have learned about drawing will help you paint better, and learning to paint will sharpen your drawing skills immeasurably.

Drawing and painting are really the same process; only the materials are different. Drawing can be described as painting with mostly dry materials on paper, and painting as drawing with brushes and paint on canvas. The decisions the artist makes when drawing are for the most part identical with those made when painting.

The projects in this chapter will help you transfer your newfound drawing skills to painting, by first working with drawing materials that will help you think like a painter, and then by making drawings with paint.

The three phases

There are three distinct phases a good drawing or a good painting passes through, even if the first phase is sometimes done entirely in the artist's head.

Composition phase. The first important consideration in any drawing or painting will be the arrangement of its *shapes*. The overall design should be planned out, either in a series of separate studies, or right on the drawing paper or canvas itself.

Value pattern phase. Once the composition has been satisfactorily established, you should develop the tonal values. To a very large extent, the success of your final picture will depend on the value pattern you develop at this point. The overall pattern of lights and darks in your picture will determine how attractive and interesting it will be. This is where many inexperienced artists fail.

Detail and finish phase. The final step in the process is detailing and finishing. After the value pattern has been established, the picture must be developed for unity and clarity. All the components of the picture must work together to form a harmonious whole, and the drawing must be clear.

It is in this final phase that a painting differs from drawing, largely due to the addition of color and the unique properties of paint. The largest step from drawing to painting is the addition of color, a whole new world so vast and exciting you will need to learn about it from other books. However, if you successfully apply what you have learned about drawing to painting, the addition of color will be only a matter of practice.

The first phase, the composition phase, may last only two or three minutes. The second phase, the value pattern phase, may last five to thirty minutes or longer, and the final phase could last for hours. However, the importance of each phase is in indirect proportion to its length: that is, the shortest phase, the first, is the most important. What you do in those first two minutes will make the biggest difference. If the composition is bad, no amount of detail will save it; but if the composition is sound to begin with, it will be a lot harder to goof it up.

Let's examine each phase in more detail on the following pages.

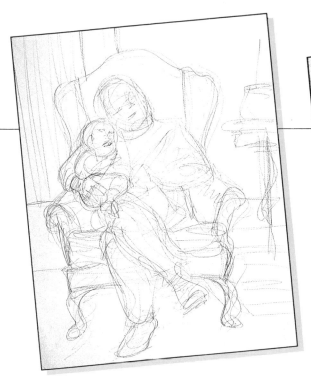

Establish the whole com-
position first.

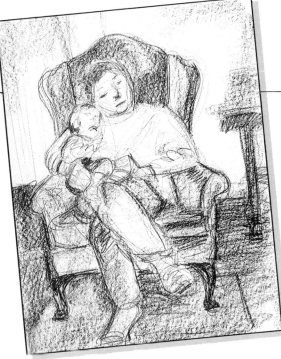

Create the overall pattern
of tonal value next.

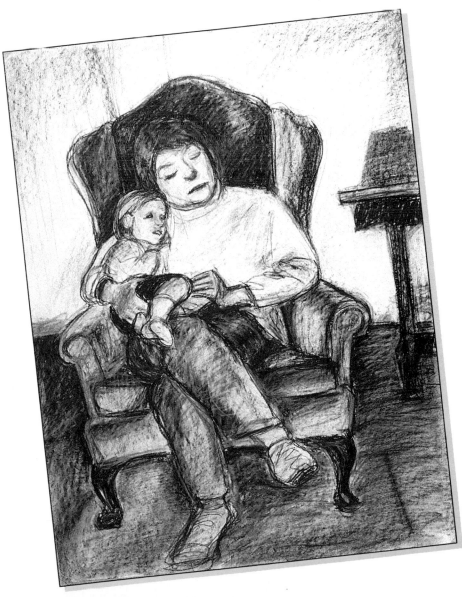

Develop and detail the
drawing last.

Some guidelines

*In the beginning, it
will help if you keep
the following sugges-
tions in mind as you
work. When you first
start, you may feel lost
with no plan of work-
ing. These guidelines
will help you deter-
mine in what order
you should do things.
The first three are
really all saying the
same thing:*

*● Work from general
to specific: Start with
simple shapes.*

*● Work from loose to
tight: Keep it loose
and free in the begin-
ning and get more
careful as the picture
progresses.*

*● Work from vague to
detailed: Suggest
things in the begin-
ning and leave detail
to later.*

*● Work from big to
small: Paint the big
shapes first, then
paint the smaller ones
on top.*

*● Work from back to
front (which usually
means top to bottom)
by doing the back-
ground stuff first,
then painting the
nearer things. You'll
find that more often
than not the areas
that are farther away
also happen to be
near the top of the
picture.*

1. Composition

The most important thing to remember about drawing for painting is to complete the composition early in the process. You want to be working on a complete composition as soon as possible.

Start the drawing with a gesture of the complete arrangement on the entire rectangle. Draw loosely, lightly and largely at first (the three "L's" of the initial drawing). Try to see the whole picture, and include all the components of the composition: the foreground, the middle ground, the figure and the background. See if you can identify a major shape formed by the little pieces. Don't break it down into smaller chunks, but do the reverse: try to put the pieces together into larger wholes.

During this phase you should be applying all the devices we have already discussed about seeing flatly and accurately. Repeatedly check your drawing against reality to be sure you are actually drawing what you see, not what you think you know. Now is the time to see all the alignments and relationships in your picture while it is relatively easy to make corrections.

Checklist

Did you:
☐ Complete the composition first?
☐ Draw loosely, lightly and largely?
☐ Look for flat shapes?
☐ See the whole picture, including the foreground, the middle ground and the background?
☐ Identify the big shapes formed by the little ones?
☐ Relate the shapes to the edges of the rectangle in an interesting way?
☐ Eliminate detail by squinting?

2. Tonal value

After you have established the gesture of the whole composition, it's time to start concentrating on the overall pattern of lights and darks. Look for the big shapes. Don't look at separate objects and identify them as things, but see them as shapes of value.

The picture, no matter how realistic it will be, must function as a good abstract design at this stage. Ignore all detail. At this point you should look for contrasts to see if the picture will "pop." The hard part at this stage is resisting the urge to put in the details or to indulge in what is called "noodling"—fussing with little adjustments in your drawing prematurely.

It takes discipline to keep searching for the pattern of value shapes. Get in the habit of seeing it and drawing it.

Effective value contrast is vital. A drawing that lacks tonal value contrast will not be very appealing to the eye. The eye is naturally drawn to areas of high contrast, and if your drawing is deficient in contrast, the viewer will not be strongly attracted to it. A drawing with only light values without any darks will look vague or faint; a drawing with only dark values will look obscure or turgid.

Checklist

Did you:
☐ Look for the big shapes of lights and darks?
☐ See the simplified value pattern by squinting?
☐ Ignore details?
☐ Create strong value contrasts?
☐ Make a good abstract design?
☐ Use a full range of values?

3. Detail and finish

The final stage is the details stage. Once you have established the pattern of values, you can spend as much time as you like adding details and refinements, making the picture clearer or more expressive. How "polished" your finished picture will be depends on what you are trying to express in your drawing.

Be prepared for the "arsenic hour": the phase when the first thrill of creating a drawing is fading, the flaws and faults are starting to become painfully obvious, but you haven't had the time yet to correct them. This is a very dangerous time, when you will be tempted to quit and start over. It is when your left side of the brain starts to undermine your confidence. You must keep working! Don't give in to the temptation to try it again. You must stay with it, practicing your ability to identify and correct mistakes as soon as you know them.

How much detail you put in your drawing, and where you put it, affects the composition. Just as sharp value contrast attracts the eye, so does more detail. The viewer's attention will be naturally drawn to those areas of the drawing that have more or sharper detail. To strengthen the focal point of your composition, you should place the greatest value contrast and the most detail at the spot you want to act as the center of interest for the viewer's eye.

Using tonal value contrast and detail to act as a magnet or anchor for the eye gives your drawing focus. You don't need to make every part of your drawing equally detailed. Be wary of overworking your drawing. Know when to quit. Too much fine detail may overwhelm the viewer. Give your drawing one main focal point.

In summary: Your drawing should first be a *complete* composition, then a *whole* pattern of tonal values, and finally *finished* with the right amount of detail. Your drawing is not done until it is *complete*, *whole* and *finished*.

Cropping

A good composition depends upon the pleasing interaction of the internal shapes of the drawing with the larger shape of the paper itself. Ideally, you should design the shapes in your drawing to work with the rectangular (or other) shape when you begin the drawing. However, it is entirely possible that the drawing will turn out to be quite different from what you first envisioned.

You must then adjust the shape of the paper by cutting it down or framing it with a mat. Adjusting the size of the visible area of a drawing is called cropping.

Cropping is an important process. One way or another, your finished drawing must be a good composition of your own design, either by plan or by cropping when the drawing is done.

Checklist

Did you:
☐ Refine and detail your drawing only after establishing the composition and value pattern?
☐ Identify and correct mistakes as soon as you recognized them?
☐ Add the most detail to the center of interest?
☐ Stop when you had just the right amount of detail?
☐ See if the composition could be improved by cropping?

To experiment with cropping on a finished drawing, use strips of paper or mat board placed on the sides of the drawing. Play with various placements of the strips until it frames the drawing in a way that creates a pleasing composition.

Charcoal and Eraser Drawing

Materials

■ White drawing paper, one 18" × 24" sheet
■ Plastic eraser and kneaded eraser
■ One stick of black Charkole or a stick of compressed charcoal

Time needed: Thirty to sixty minutes or longer

Essential to the process of playing while you draw is the ability to make changes and corrections on your drawing quickly and easily. You must be able to readily modify your drawing as you go, making the decisions that will slowly bring the drawing to the condition that satisfies you.

Therefore, you should work with materials that allow you to make constant changes with little difficulty, especially when you're learning to draw better. Work with materials that stay workable and correctable to the end. The exercises in this chapter feature materials that will keep the drawing workable until the drawing is finished.

In this project, you will work with a piece of Charkole or compressed charcoal and the plastic and kneaded erasers. The erasers are drawing tools for manipulating the charcoal on the surface of the paper as well as devices for making corrections.

Before you begin, cover the paper with Charkole. Rub the side of a stick over the entire surface and then smear it evenly with tissue.

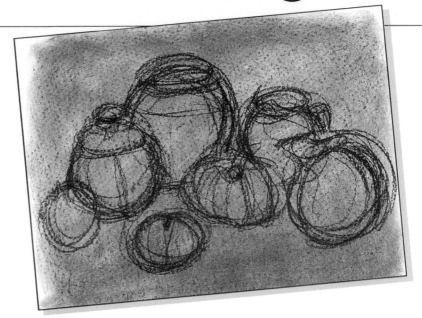

1

The composition is loosely indicated in the manner of a gesture drawing.

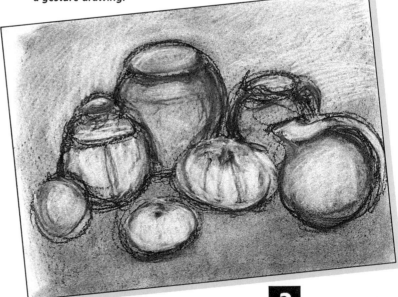

2

Begin to establish the value pattern by using the eraser to lighten areas of the drawing. At this point, everything is tentative and inexact.

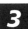 **3**

By using the eraser to lighten some areas and the charcoal to darken others, continue to refine and clarify the pattern of lights and darks in the drawing.

4

Use the tissue, your fingertip, or the eraser to smear the charcoal around on the paper. Think of the eraser as a tool to manipulate the powder deposited on the paper. Begin adding details.

5

Continue adding details and adjusting edges and tonal values until you are satisfied with your drawing. Just how detailed your drawing will be is a matter of personal artistic judgment.

Charcoal and Chalk on Gray Paper

Materials

■ *One stick of soft white blackboard chalk or a 2B white Conté crayon*
■ *One stick of black Charkole, soft-compressed charcoal or a 2B black Conté crayon*
■ *One sheet of 18" × 24" gray charcoal paper*
■ *Plastic eraser*
■ *Kneaded eraser*

Time needed: *An hour or more depending on the complexity of the subject matter and the degree of detail desired*

This exercise is the closest thing you will do to making a drawing that resembles a black-and-white photograph of your subject. Like a camera with black-and-white film, you are transforming color into value. Dark colors and objects in shadow become dark grays, and light or bright colors and objects in the light become light grays or white.

Unlike a camera, you are an intelligent agent capable of making subtle adjustments in your drawing that will make it more interesting, clearer, and more expressive than any mechanical or photographic process ever could.

You will need to simplify and generalize many of the differences in tonal value that you see. You will have to make judgments about how to reduce the myriad tonal values you see to a few rather exaggerated value differences.

Your drawing should progress in three distinct phases: 1) Establish the composition. Include all the shapes in the foreground, middle ground, and background as well. Take the lines all the way to the edges of the paper. 2) Then draw the tonal pattern. 3) Finally, add details.

1

The Composition—*Begin with a gesture drawing of the whole arrangement of your subject matter, using either the black or white chalk. Take the lines all the way to the edges of the paper; don't noodle around in the center.*

2

Tonal Pattern—*Begin establishing the shapes of light and dark. The Charkole and chalk can be scribbled over each other, letting the strokes blend on the paper into the shades of gray you need. Ignore detail. Your objective in this phase is to eliminate the gray of the paper by covering every square inch with grays of your own making.*

3

The Detail and Finish Phase—*Once the patterns of light and dark have been established, begin adding details. Step back from your drawing and look at it carefully. Ask the following: How can I make the shapes look three dimensional? How can I create more depth? How can I make the drawing clearer?*

Comments

Although you may not really see any shapes that are a pure white or any shapes that are a true black, you will have to make some lights white and some darks black to distinguish what is closer to you and what is farther away.

4

The Finished Drawing—
Add all the final subtleties, details and nuances.

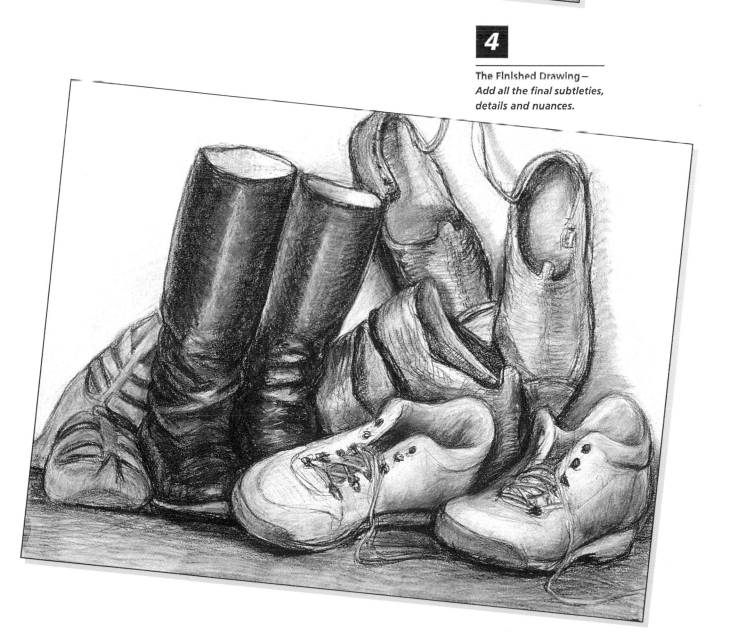

Black and White Acrylic on Gray

Materials

- Tube of black acrylic paint
- Tube of white acrylic paint
- ¼-inch oil painter's flat bristle brush
- ½-inch oil painter's flat bristle brush
- Flat nonporous palette such as a plastic tray, aluminum pie pan, dinner plate, enamelled butcher's tray
- Containers for water
- Roll of paper towels
- One sheet of 18" × 24" gray charcoal paper
- Apron or smock or old clothes

Time needed: *Two to three hours*

It's time to paint! Drawing and painting are the same basic process with different materials. Drawing can be thought of as painting with dry materials on paper, and painting as drawing with brushes and paint. In this project, you will follow the same procedure as you did in the previous exercise, but with black and white paint instead of black and white chalk.

Your painting will go through the same phases: First establish the composition, then the pattern of lights and darks, and then finish.

Because of their rapid drying time, acrylics let you make corrections and adjustments easily (see sidebar). You can paint and repaint anything that is not right, putting layer upon layer of acrylic until you are satisfied.

In the process of ''playing'' with your painting, you will make some choices that turn out not to your liking. That doesn't mean they were bad choices or mistakes. It is all part of the try-it-and-see-what-happens method. So if you paint something that you don't like, change it! Always maintain the total willingness to identify the flaws and errors in your drawing, and the willingness to start making them better.

A lot is going on in this particular exercise. It is probably one of the most important to master. It is one worth repeating many times, with a variety of subject matter. In fact, if there was just one exercise to do, I would probably pick this one. It strengthens all the important drawing skills: gesture, composition, values, finish.

1

Begin by painting a loose gesture of your entire subject matter. Work with a fairly thin mixture of either white or black paint. Remember to include the background and foreground shapes. What you do in this step will have a big impact on the final painting. Don't settle for an accidental composition.

2

Begin painting the overall pattern of light and dark shapes. Start thinking shapes as soon as the gestural underpinnings are in place. Try to reduce your subject matter to a few simple shapes of light and dark and paint them first. Make sure your drawing is correct by constantly comparing the shapes you paint with the shapes you see.

3

Continue defining and refining the light and dark shapes. At this point, detail is the enemy! Now is the time to simplify and exaggerate the value differences.

4

Painting is an adjustment process. Step back and assess your progress periodically. Look for areas that are confusing or unclear.

Painting with acrylics

Acrylic paint remains water soluble while wet, but dries rapidly into a flexible waterproof film.

Keep your brushes wet; don't let the paint dry out on the bristles.

The advantage of painting with acrylics is that they dry so quickly. The disadvantage is that they dry so quickly! The fast drying time enables the artist to paint over areas that need adjustment with five or ten minutes of painting, but it is difficult to paint subtle tonal gradations before the paint becomes unworkable.

Painting with acrylics encourages quick and decisive brushwork, but since it allows almost unlimited overpainting, mistakes are easily corrected.

5

Stop when you are satisfied with the amount of detail you have included in your drawing. Not all of the painting needs the same amount of detail, but no part should look neglected.

Black and White Oil on Canvas

Materials

- Tube of black oil paint
- Tube of white oil paint
- ¼-inch "flat" oil painter's bristle brush
- ½-inch "flat" oil painter's bristle brush
- No. 1 round oil painter's bristle brush
- Flat nonporous palette or disposable palette pad
- Odorless artist's turpentine
- Container for turpentine; clean tuna can is ideal
- Roll of paper towels or rags
- 18" × 24" canvas panel
- Apron or smock or old clothes

Time needed: Two to three hours

This project is essentially the same as the last two. Instead of using black and white chalk or acrylic paint on paper, you will use oil paint. Regardless of the medium you use, the painting or drawing first starts as a complete composition, then develops into a pattern of light or dark shapes, and is finally completed with the right details.

If you keep this three-step process in mind, it will be much easier to relate what you know about drawing to painting.

Before starting your painting, you might want to first mix a little black with turpentine and use a soft rag to apply a very thin tint on the canvas. Let it dry before painting. It is easier to judge values on a gray or off-white surface; a glaring white canvas is not only intimidating, it makes all grays look darker by contrast.

Most oil paints in tubes contain plenty of oil and do not require a special medium (such as linseed oil mixed with turpentine). Two small containers of turpentine, one for thinning paint, the other for cleaning brushes, should be kept handy.

Keep your brushes clean; wipe off the excess paint on paper towels and dispose of them properly. When finished, clean the brushes with turpentine and wash them with mild soap and warm water. Avoid getting the paint and turpentine on your skin.

1

Mix a little black paint with turpentine to an ink-like consistency. Use the round brush to establish the composition. Because you can easily overpaint with oils, take the time to establish the correct shapes. Use a paper towel or rag to wipe out any mistakes.

2

When you are satisfied with the underdrawing, paint in the value pattern with the larger brush. Think in terms of mapping shapes. Your painting might resemble a paint by number painting at this point.

3

Begin the process of refining and detailing your painting. Use the largest brush you can. Small brushes will encourage "noodling."

Painting with oils

Oil paint is made from pigment mixed with an organic oil usually derived from vegetable matter such as linseeds. It is thinned with solvents such as turpentine. Oil paint usually takes more than twenty-four hours to dry, and varies considerably from color to color.

Oils are not as convenient as acrylics because they require toxic solvents. They should only be used in an area ventilated with fresh air, and should be avoided completely during pregnancy.

The advantage of painting with oils is that they dry slowly. The disadvantage is that they dry slowly! The slow drying time enables the artist to paint subtly blended areas and very soft edges, but it is difficult to overpaint areas without disturbing the still wet paint underneath.

Painting with oils encourages more deliberate planning because mistakes are not as easily corrected as with acrylics.

4

Stop when you have achieved the "finish" you desire. The paint will dry to the touch overnight, and you can continue painting the next day without disturbing the previous layers of paint.

Exploring Personal Expression

There are many reasons for learning to draw better. To begin, drawing is a fun thing to do, and requires no more justification than that. In fact, drawing for the heck of it might be one of the best reasons for doing it and may very well create the best results.

Drawing heightens your awareness and sensitivity. As we have seen, learning to draw means renewing the way we see things. You must learn to look for different visual clues. As you develop this ability, a whole new realm of experience becomes available to you. You begin to see things in a new and fresh way. The world can be rediscovered as a beautiful, marvelously textured place. For me, this alone is good enough reason to draw, even if all my efforts never resulted in a ''good'' drawing.

Another compelling reason for learning to draw is its potential for personal expression and self-discovery. Drawing is naturally expressive. No matter how hard you tried, you could never create a drawing that wasn't automatically an expression of your own personality. You don't have to try to make your drawings ''arty'' or emotional. Even a simple contour drawing done as an exercise will be a unique expression of your own perceptual abilities. You may have noted the expressive quality of your gestures and contours, even though that was not a conscious aim on your part.

Finally, drawing is creative. Creativity and drawing are, in fact, mutually stimulating. Several educators have shown how personal creativity can be enhanced by learning to draw, and how learning to draw can be facilitated by creative activity.

Although you can't force creativity (it's like being deliberately spontaneous), you can facilitate the creative process. Begin by being conscious of making your drawings more than just a mechanical production.

Tips for boosting personal expression

● **Make a list of the things that interest you.** This list does not have to be related to drawing. It is a personal inventory of what you find fascinating in the world, including your sports, hobbies, friends, activities, dreams, etc.

There are no limits. Use the list for ideas of things you might like to draw. Here's a list of some things that have fascinated me for a long time:

- maps
- rubber stamps
- Tarot cards
- models of ships and trains
- postcards of Paris
- castles
- board games of all sorts
- nineteenth-century woodcut book illustrations
- the American Civil War
- folk art and costumes
- musical instruments

Just compiling the list should make you feel excited. I like to take items from my list and see what happens if I combine two of them (even at random) to see what the juxtaposition suggests.

● **Make a list of the artists you admire and identify a quality they share.** The more I study art and art history, visit museums, and read books, the fewer artists I really admire, but my admiration for those few grows and grows. At the top of page 129 is a short list of artists I like. Looking at their work never fails to give me the urge to draw.

● **Start and maintain a sketchbook journal.** Lots of artists keep a sketchbook that is a combination scrapbook, diary and artistic journal. By its very nature a sketchbook is a personal thing, so I am not going to suggest a certain size or even how to use it. It can be a large artists' sketchbook, a pocket notebook, a three-ring binder. All you need is something that can serve

- Delacroix
- Edward Hopper
- Georges Seurat
- Paul Cadmus
- Käthe Kollwitz
- Paul Klee
- Rico Le Brun
- Grant Wood
- Giovanni da Bologna

as a handy repository of ideas, doodles, etc.

Use the sketchbook as a personal "idea trap." Draw in it, doodle in it, make notes in it. Tape clippings from magazines if you want. Make diary entries in it if you want. It doesn't even need any drawings or sketches at all. It can be a place to record your thoughts and feelings about drawing.

I do have one suggestion: don't show anyone the sketchbook you are working in currently. You want to have a place to draw that is completely free from any outside judgments. The idea that someone might see your work could subtly undermine your desire to be "good" rather than sincere. Your journal should be for you and you alone.

● **Start an idea file.** Create a file and fill it with every visual delight you find such as magazine clippings, cartoons, photographs, reproductions, doodles and sketches, and anything else you find that you consider visually stimulating, interesting and beautiful. Refer to the file periodically for ideas and inspiration.

Your personal idea file can be a file folder in a small filing cabinet, a small portfolio, or a scrapbook. If keeping a scrapbook sounds tedious, hang a corkboard in your studio and pin up whatever "turns you on" visually. Your idea file

can even be a cardboard box. At least keep a pile of visual goodies somewhere. For a long time I just kept a small box in my studio into which I slipped anything of interest. Don't let anything that might spark your imagination slip away due to the lack of an idea file.

● **Enlist the support of family and friends by offering your support for their endeavors in exchange.** It's hard to get the time and space to concentrate on drawing, even for half an hour, if your family doesn't understand what you are doing. The best way to gain their cooperation is to deliberately make a deal with the members of your family. Tell them what you are doing and why and offer to support a comparable activity of their own.

● **Form or join an art critique class that meets to discuss artwork in a supportive, healthy way.** Doing anything completely on your own is more difficult than doing something when you can share with others. It is a tremendous boost if you can discuss your work with other like-minded artists. Some of the most instructive and insightful experiences for me are group critiques in my drawing class when I just shut up and listen to the students.

The easiest way to form a group is to attend a class or open drawing studio and make friends and then invite them to an informal critique. Always keep it positive. The purpose is to extend mutual support.

● **Read every book on drawing you can find.** See the bibliography at the end of this book. Everyone has something of value to offer. I found these to be the best of many good books. Some books will contradict this book. Neither is right or wrong. Pick what works for you. Even books that I thought weren't all that great still offered something worthwhile.

● **Use affirmations to maintain a healthy inner dialogue — the little voice in your head.** I am convinced that your thoughts and attitudes really do have a more than subtle influence on your work and how you feel about it. You don't need a mantra running through your head, nor do you have to fall asleep

saying, "Every day in every way my drawings are getting better and better," but you do need to remind yourself periodically that smart practice *will* make a difference.

● *Be yourself.* I know it's a cliché, but for good reason. Do what you do for the right reason. Own what you do. Learning anything requires a certain amount of dedication and humility, and that goes for learning tennis or a foreign language as well as drawing. A sincere artistic statement, even if it is technically flawed or unsophisticated is always more appealing than the slickest superficiality.

● *Never indulge in negative comparisons.* Don't compare yourself to anyone else. There will always be somebody better and somebody worse. There is nothing to learn in that. You can compare your work to another's to figure out how to make your own better, but never to make yourself feel inferior.

Appreciate the value of your art simply because you did it. You should be proud of what you are doing, not because it glorifies your own ego, or that it is better than someone else's, but because it is simply worth doing.

● *You don't have to be original.* There is no need to be obsessed with finding something new or trying to do something no one else has ever done. Remember, there is nothing new under the sun. It is almost impossible to consciously make something truly new. Of course, it is also true you can't step in the same river twice! Just as no two people have the same handwriting, no two artists will have the same style. Your own style will evolve naturally. It will be the result of your own discoveries, mixed with the influences of artists you admire, teachers you may have, and many other influences.

● *Keep the pump primed.* Practicing daily even for a short time is better than practicing for long periods of time far apart. Take care of your work. Store the good stuff properly. Have a conducive place to work, but don't get obsessed with it. Carry a notebook and use it. Do drawings in your head.

● *Challenge your assumptions, habits and attitudes.* One of the best ways to grow is to look at the way you always do things and make a change, however modest, in your routine. We all have our own "standard operating procedures" that we almost never question, doing the same old thing the same old way all the time. Try varying the formula. Whenever we can break out of the mold, we can see things a bit differently and can think more creatively.

Never indulge in negative comparisons.

Conclusion

Perhaps "play" is the best word to describe the process of drawing. Think of drawing as a form of play, in which you are free to try different things for the fun of it, just to see what it will look like. Drawing is often a process of trial and error, of experimentation and adjustment. But for drawing to be a form of play, you need a playful attitude. You must feel a freedom to explore, an openness to change, and fearlessness of mistakes.

Learn to enjoy the very act of drawing. Practice focusing on the drawing you are doing, rather than indulging in self-criticism. Ignore your internal critic, that little voice in your head that spoils the fun of drawing. Drawing should feel good, no matter how the final drawing turns out. Every drawing session will be successful if you are always willing to learn.

Writing this book has given me a renewed understanding of the importance of maintaining a playful attitude. Working on it reminded me of what it is often like for someone learning to draw. I was beset by all the doubts, misgivings and frustrations I remember experiencing when I first started to draw.

In short, I was doing everything I advise students not to do when they are learning to draw. It had stopped being fun. What restored my joy and enthusiasm was reminding myself what this book was all about. I sincerely want this book to be about helping you, the reader, make better drawings. When that goal was foremost in my mind, rather than other concerns, I once again felt excitement about sharing the delights of drawing through this book.

I hope your experience with this book justifies its title. As I stated in the introduction, you can't learn to draw by reading about it. You can learn to draw only by drawing and drawing. If you relax, allow yourself to have fun, and draw, draw, draw, you will see that you CAN do it!

Troubleshooting Guide

Use this chart to identify any drawing problems with which you are having particular trouble and find out what projects in this book will help you make your drawings better.

Problem	Comments	Solution
I want to draw what I see more accurately.	Contour drawing, done conscientiously with a wide variety of subject matter, is the best way to increase your ability to draw accurately.	Practice doing blind contour, pages 24-35, and sneak-a-peek contour, pages 36 and 37.
I want to loosen up to draw more freely and expressively.	All too often, we learn to be cautious and careful when we draw, trying to avoid making mistakes. Tentative, stiff drawings result. A gesture drawing takes only minutes to do and encourages you to work freely.	To break free of inhibitions and loosen up, do a lot of gesture drawing as described in Chapter Four.
I want to make my drawings eye-catching and intriguing.	The key to pictures that attract the eye and engage the viewer's interest is tonal value. Strong contrast of light and dark in your picture is the most effective way to draw the viewer's attention.	The exercises in Chapter Eight will help you see and draw the underlying pattern of values in your subject matter.
I want to find my own unique style.	Your drawing style will be as unique as your handwriting. Most artists develop a style that tends to favor either contour or gesture. Experimentation will help you find a mix of contour and gesture that can be the basis for a comfortable and natural drawing style.	Quick contour, pages 42 and 43, and extended gesture, page 64, allow you to blend the accuracy of contour with the spontaneity of gesture in various ways.
I want to give my drawings the illusion of depth.	Drawing the lights and darks around your subject matter defines the space in which it exists and enhances the illusion of distance between the objects in your drawing.	Chapters Eight and Nine contain exercises that encourage you to draw both your subject matter and its environment. Modeled drawing, Chapter Six, will teach you how to place your subject matter in space so your drawings don't look flat.
I want to make my drawings look more complete.	Composition is the art of making your pictures look satisfyingly complete. "Think compositionally," seeing the entire picture as an integrated whole, and seeing through the details to organize the tonal values in your drawing into a cohesive whole.	The exercises in Chapter Seven help you "think compositionally," and the exercises in Chapter Eight help you see the underlying pattern of lights and darks in your drawing.
I want to make my figure drawings look less stiff and more alive.	Gesture drawing is the answer. Gesture drawings of people can be done almost anywhere, anytime. Doing a few gesture drawings every day is a great way to learn how to make your figures more lifelike and more natural.	See pages 52-55 for tips on doing scribble drawings of the figure. You can do them in your sketchbook (page 3) and even while watching TV (page 60).
I want to make my drawings clearer.	Lack of tonal contrast makes a picture unclear or muddy, especially if two adjacent shapes are the same value.	The simple shape projects in Chapter Eight will help you identify and simplify the shapes of tonal value that you need to draw a clear picture.
I want to improve my painting by learning to draw better.	Many of the flaws and faults artists detect in their paintings are really drawing problems. Common deficiencies are inaccuracies or mistakes in drawing what you see; and the failure to first compose an underlying pattern of tonal values.	Review Chapter Two, which contains techniques to develop your ability to draw three-dimensional forms as flat shapes, and do lots of contour compositions (pages 96 and 97) to improve your drawing accuracy. Value compositions in graphite (pages 106 and 107) and in charcoal (page 109) will help you compose your pictures with lights and darks.

Bibliography

You can't learn to draw by reading books. You can only learn by drawing many, many drawings and by drawing a little every day until it is a part of your life. However, you *can* learn much about drawing from books that will make your drawing experiences richer and more fun. I have listed below the books that I think are great sources of ideas and inspiration. They are listed in the order I recommend you read them. Each one takes a very different approach to drawing from the book you are reading now, and together will give you many ideas for understanding how we must learn to see anew when we draw.

Drawing on the Right Side of the Brain

Betty Edwards, 1989, J.P. Tarcher, Los Angeles, CA.
If there was one book I would recommend for the beginner, it is Betty Edwards's book. Since its publication, it has become a classic, and for good reason. No other book explains so well why we must learn to use our brain and our eyes in a new way when we draw. Her explanation of the way the two hemispheres of our brain work and how the drawing student must engage the right side while subduing the left is superb. Read it and do the exercises she describes.

Keys to Drawing

Bert Dodson, 1985, North Light Books, Cincinnati, OH.
This is the most thorough and comprehensive book on drawing you can read. It is a gold mine of information. It not only contains many exercises that will improve your drawing skills, it lists over fifty "keys to drawing" that crystallize the most important concepts the student should learn. *Keys to Drawing* is worth reading and re-reading.

The Natural Way to Draw

Kimon Nicolaides, 1941, Houghton Mifflin, Boston.
This book was first published in 1941 and has been inspiring and instructing artists ever since. Gesture and contour were first described in this classic instruction book. In fact, many of the exercises in this book and many others, were first introduced by Nicolaides. As the author states on page 1, the book is meant to be used. It contains a course of instruction, complete with tables of daily exercises, that the student should follow to gain the maximum benefit from it. Unfortunately, many would-be artists have Nicolaides's book, but not many have had the discipline to use it as intended. Nevertheless, the book contains so many great ideas and is such a practical approach to drawing that every serious student should be familiar with it.

The above three books are the only books that every drawing student *should* read and study. However, there are many good books. The following are the ones that I recommend— *after* you have read the ones above.

Drawing Without Fear

R. Rafaello Dvorak, 1987, Dale Seymour Publications, Palo Alto, CA.
A book to inspire and encourage the beginner. If you begin to feel discouraged or doubtful of your ability to improve your drawing, turn to this book.

Experiential Drawing

Robert Regis Dvorak, 1991, Crisp Publications, Inc., Los Altos, CA.
An excellent guide to freeing your imagination and sparking creativity through drawing. Experiential drawing focuses on the process of drawing, since it is in the act of drawing itself, not in technique, in the end product, or in "the rules of drawing" the miracle of seeing the world in a new and fresh way occurs.

Drawing on the Artist Within

Betty Edwards, 1987, Simon & Schuster, New York.
In this book, Edwards builds on many of the concepts introduced in her *Drawing on the Right Side of the Brain*. She guides readers through the process of releasing their creativity through drawing in ways that can effect all areas of their lives. It will improve your drawing and your creative powers.

Other books that use drawing to improve your thinking and creativity skills worth a look are:

Experiences in Visual Thinking

Robert McKim, 1980, Brooks-Cole Publishing Co., Pacific Grove, CA.

Drawing: A Creative Process

Francis D.K. Ching, 1990, Van Nostrand Reinhold, New York.

Draw! A Visual Approach to Thinking, Learning, and Communication

Kurt Hanks and Larry Belliston, 1977, William Kaufmann, Inc., Los Altos, CA.

Teaching Your Child to Draw: Bringing Out Your Child's Talents and Appreciation for Art

Mia Johnson, 1990, Lowell House; Contemporary Books: LA and Chicago

Drawing with Children: A Creative Teaching and Learning Method That Works for Adults, Too

Mona Brooks, Jeremy P. Tarcher, Inc., La: Distributed by St. Martin's Press.

Index

Improve your skills, learn a new technique, with these additional books from North Light

Business of Art

Artist's Friendly Legal Guide, by Floyd Conner, Peter Karlan, Jean Perwin & David M. Spatt $18.95 (paper)

Artist's Market: Where & How to Sell Your Graphic Art, (Annual Directory) $22.95

The Complete Guide to Greeting Card Design & Illustration, by Eva Szela $29.95

How to Draw & Sell Comic Strips, by Alan McKenzie $19.95

Art & Activity Books For Kids

Draw!, by Kim Solga $11.95

Paint!, by Kim Solga $11.95

Make Cards!, by Kim Solga $11.95

Make Clothes Fun!, by Kim Solga $11.95

Make Costumes!, by Priscilla Hershberger $11.95

Make Prints!, by Kim Solga $11.95

Make Gifts!, by Kim Solga $11.95

Make Sculptures!, by Kim Solga $11.95

Watercolor

Basic Watercolor Techniques, edited by Greg Albert & Rachel Wolf $14.95 (paper)

Buildings in Watercolor, by Richard S. Taylor $24.95 (paper)

The Complete Watercolor Book, by Wendon Blake $29.95

Fill Your Watercolors with Light and Color, by Roland Roycraft $28.95

How To Make Watercolor Work for You, by Frank Nofer $27.95

Jan Kunz Watercolor Techniques Workbook 1: Painting the Still Life, by Jan Kunz $12.95 (paper)

Jan Kunz Watercolor Techniques Workbook 2: Painting Children's Portraits, by Jan Kunz $12.95 (paper)

The New Spirit of Watercolor, by Mike Ward $21.95 (paper)

Painting Nature's Details in Watercolor, by Cathy Johnson $22.95 (paper)

Painting Watercolor Portraits That Glow, by Jan Kunz $27.95

Splash I, edited by Greg Albert & Rachel Wolf $29.95

Starting with Watercolor, by Rowland Hilder $12.50

Tony Couch Watercolor Techniques, by Tony Couch $14.95 (paper)

The Watercolor Fix-It Book, by Tony van Hasselt and Judi Wagner $27.95

Watercolor Impressionists, edited by Ron Ranson $45.00

The Watercolorist's Complete Guide to Color, by Tom Hill $27.95

Watercolor Painter's Solution Book, by Angela Gair $19.95 (paper)

Watercolor Painter's Pocket Palette, edited by Moira Clinch $15.95

Watercolor: Painting Smart, by Al Stine $27.95

Watercolor Tricks & Techniques, by Cathy Johnson $21.95 (paper)

Watercolor Workbook: Zoltan Szabo Paints Landscapes, by Zoltan Szabo $13.95 (paper)

Watercolor Workbook: Zoltan Szabo Paints Nature, by Zoltan Szabo $13.95 (paper)

Watercolor Workbook, by Bud Biggs & Lois Marshall $22.95 (paper)

Watercolor: You Can Do It!, by Tony Couch $29.95

Webb on Watercolor, by Frank Webb $29.95

The Wilcox Guide to the Best Watercolor Paints, by Michael Wilcox $24.95 (paper)

Mixed Media

The Artist's Complete Health & Safety Guide, by Monona Rossol $16.95 (paper)

The Artist's Guide to Using Color, by Wendon Blake $27.95

Basic Drawing Techniques, edited by Greg Albert & Rachel Wolf $14.95 (paper)

Being an Artist, by Lew Lehrman $29.95

Blue and Yellow Don't Make Green, by Michael Wilcox $24.95

Bodyworks: A Visual Guide to Drawing the Figure, by Marbury Hill Brown $10.95

Business & Legal Forms for Fine Artists, by Tad Crawford $4.95 (paper)

Capturing Light & Color with Pastel, by Doug Dawson $27.95

Colored Pencil Drawing Techniques, by Iain Hutton-Jamieson $24.95

The Complete Acrylic Painting Book, by Wendon Blake $29.95

The Complete Book of Silk Painting, by Diane Tuckman & Jan Janas $24.95

The Complete Colored Pencil Book, by Bernard Poulin $27.95

The Complete Guide to Screenprinting, by Brad Faine $24.95

Tony Couch's Keys to Successful Painting, by Tony Couch $27.95

The Creative Artist, by Nita Leland $12.50

Creative Painting with Pastel, by Carole Katchen $27.95

Drawing & Painting Animals, by Cecile Curtis $26.95

Drawing: You Can Do It, by Greg Albert $24.95
Exploring Color, by Nita Leland $24.95 (paper)
Fine Artist's Guide to Showing & Selling Your Work, by Sally Price Davis $17.95 (paper)
Getting Started in Drawing, by Wendon Blake $24.95
The Half Hour Painter, by Alwyn Crawshaw $19.95 (paper)
Handtinting Photographs, by Martin and Colbeck $29.95
How to Paint Living Portraits, by Roberta Carter Clark $28.95
How to Succeed As An Artist In Your Hometown, by Stewart P. Biehl $24.95 (paper)
Keys to Drawing, by Bert Dodson $21.95 (paper)
The North Light Illustrated Book of Painting Techniques, by Elizabeth Tate $29.95
Oil Painting: Develop Your Natural Ability, by Charles Sovek $29.95
Oil Painting: A Direct Approach, by Joyce Pike $22.95 (paper)
Oil Painting Step by Step, by Ted Smuskiewicz $29.95
Painting Floral Still Lifes, by Joyce Pike $19.95 (paper)
Painting Flowers with Joyce Pike, by Joyce Pike $27.95
Painting Landscapes in Oils, by Mary Anna Goetz $27.95
Painting More Than the Eye Can See, by Robert Wade $29.95
Painting Seascapes in Sharp Focus, by Lin Seslar $10.50 (paper)
Painting the Beauty of Flowers with Oils, by Pat Moran $27.95
Painting the Effects of Weather, by Patricia Seligman $27.95
Painting Towns & Cities, by Michael B. Edwards $24.95
Pastel Painter's Pocket Palette, by Rosalind Cuthbert $16.95
Pastel Painting Techniques, by Guy Roddon $19.95 (paper)
The Pencil, by Paul Calle $19.95 (paper)
Perspective Without Pain, by Phil Metzger $19.95 (paper)
Photographing Your Artwork, by Russell Hart $18.95 (paper)
Putting People in Your Paintings, by J. Everett Draper $19.95 (paper)
Realistic Figure Drawing, by Joseph Sheppard $19.95 (paper)
Tonal Values: How to See Them, How to Paint Them, by Angela Gair $19.95 (paper)

Crafts & Home Decorating

The Complete Flower Arranging Book, by Susan Conder, Sue Phillips & Pamela Westland $24.95
Contemporary Crafts for the Home, by Bill Kraus $10.50
Creative Basketmaking, by Lois Walpole $12.95
Creative Paint Finishes for the Home, by Phillip C. Myer $27.95
Decorative Painting for Children's Rooms, by Rosie Fisher $10.50
The Dough Book, by Toni Bergli Joner $15.95
Festive Folding, by Paul Jackson $17.95
Great Gifts You Can Make in Minutes, by Beth Franks $15.95 (paper)
Make Your Woodworking Pay for Itself, by Jack Neff $16.95 (paper)
Master Strokes, by Jennifer Bennell $27.95
Painting Murals, by Patricia Seligman $26.95

To order directly from the publisher, include $3.00 postage and handling for one book, $1.00 for each additional book. Allow 30 days for delivery.

North Light Books
1507 Dana Avenue, Cincinnati, Ohio 45207
Credit card orders call TOLL-FREE
1-800-289-0963
Stock is limited on some titles; prices subject to change without notice.